REMEMBERING
MONROEVILLE

REMEMBERING
MONROEVILLE
From Frontier to Boomtown

ZANDY DUDIAK

Published by The History Press
Charleston, SC 29403
www.historypress.net

Copyright © 2009 by Zandy Dudiak
All rights reserved

First published 2009
Second printing 2012

Manufactured in the United States

ISBN 978.1.59629.705.0

Library of Congress Cataloging-in-Publication Data

Dudiak, Zandy.
Remembering Monroeville : from frontier to boomtown / Zandy Dudiak.
p. cm.
Includes bibliographical references and index.
ISBN 978-1-59629-705-0 (alk. paper)
1. Monroeville (Pa.)--History. I. Title.
F159.M775D83 2009
974.8'85--dc22
2009026262

Notice: The information in this book is true and complete to the best of our knowledge. It is offered without guarantee on the part of the author or The History Press. The author and The History Press disclaim all liability in connection with the use of this book.

All rights reserved. No part of this book may be reproduced or transmitted in any form whatsoever without prior written permission from the publisher except in the case of brief quotations embodied in critical articles and reviews.

CONTENTS

Acknowledgements 7
Introduction 9

Part I. Days of Yore
From Tulpewi Sipi to Monroeville 11
A Trail through the Woods 15
Good Old Log Cabins 19
Stagecoach a'Comin' 23
A Tale of Two Churches 28

Part II. Settling Into the Rural Life
The Widow Miers 33
The Johnstons: A Homesteading Family 37
The Monroe in Monroeville 40
School Days 43
Down on the Farm 47

Part III. Whistles, Wheels and Wings
The Tracks of Progress 51
The First William Penn Highway 55
Takeoff 58
A Highway and Byway 61
Hub of the Suburbs 65

Contents

Part IV. An Industrial Evolution

Train Town 71
You Can Be Sure, if It's Westinghouse 74
Research Capital of the Nation, Gateway to the World 78

Part V. That's Entertainment

An Amusement Park's Rollercoaster Ride 83
The Roadhouse 87
Going, Going, Sold 91
Cruisin' the Miracle Mile 93
Holiday House: Where the Stars Came to Shine 98
Dawn of the Mall 101
On Thin Ice 105

Part VI. In the End

Workin' in a Coal Mine 109
Life and Death…and in Between 114
Together for Eternity 118

Bibliography 123
About the Author 127

ACKNOWLEDGEMENTS

Louis and Lynn Chandler
Marilyn Chandler
Lillian DeDomenic
Dom DeDomenic
Billy Gentile
Colleen Eliese Gribbin
Jonathan Gribbin
Edith Hughes
Bob Mock
Ella Ridgeway
Sandy Stuhlfire
The It's Alive Show
Joan Ridgeway Walton
Marilyn Wempa

INTRODUCTION

Monroeville, the eastern gateway to Pittsburgh, Pennsylvania, is a place where fast interstate highways and traffic-laden state routes merge at one of the state's busiest intersections. On the same land where bright lights draw shoppers to a multitude of stores and a plethora of fast-food eateries entice strings of cars both day and night, there was once nothing but forest, animals, skies, stars and a few American Indians.

Monroeville—the municipality as it exists today—was a late yet quick bloomer.

Even though its first permanent settler arrived about 1778, Monroeville was mostly rural farmland into the 1950s. The land was too far away from waterways and mainline railroads to develop the way many other small towns did around Pittsburgh before the advent of the automobile. There was no real main street, unless you count the stretch on which a few small businesses and homes sprouted along the Northern Turnpike in the hamlet known as Monroeville back in the mid-1800s.

That hamlet was unimpressive to the outside world. The 1889 *History of Allegheny County* published by A. Warner & Co. of Chicago, said of Monroeville: "The village is merely a straggling hamlet and possesses no importance."

To understand how Monroeville transitioned from forest and farm to a vital suburban commercial hub, one must take those highways and trails back through time.

Part I
Days of Yore

From Tulpewi Sipi to Monroeville

In quiet woods, where deer roamed and squirrels played, Native Americans once hunted for their food. The Iroquois and Algonquin came first, followed by the Cherokee, Seneca and Erie tribes. Later, the Shawnee and Delaware passed through, leaving paths behind that were later used by early white soldiers and settlers.

Historians believe the area that is now Monroeville was the site of many battles, given the arrowheads, hatchets and tomahawk heads discovered in later years. A Monongahela tribe village just over the boundary between the present-day Monroeville and Plum Borough, dating from between AD 900 and 1600, was excavated by Plum resident Kirk Wilson in 1966. Anthropologists from the University of Pittsburgh searched the area a decade later but found few artifacts, indicating that the village was most likely short-lived. It also may have been under siege, evidenced by the many arrowheads and a burial area found nearby.

By 1730, Pennsylvania traders estimated that there were fewer than seven hundred warriors in the Upper Ohio Valley, though there were skirmishes with early local settlers. At the time that pioneers started to settle east of Pittsburgh, the area that today comprises the central East Suburbs was known only as Turtle Creek, translated from the Delaware Indian name *Tulpewi Sipi*, or "slow-moving river of turtles." The area had been the setting of a Delaware camp in the bottomlands where the creek provided an abundance of fish and turtles.

There were no municipal boundaries in the days of the first settlers, and even the state boundaries were in question. The colonies of Virginia and Pennsylvania entered into a dispute in 1754 over the ownership of the southwest corner of Pennsylvania, caused by the boundless dominions

of their early Crown charters. The French also laid stake to a claim for ownership. The dispute continued through the French and Indian War and Revolutionary War until commissioners for the two states were appointed in 1780 to draw proper boundaries, which were established in 1784.

The Turtle Creek area started as part of Lancaster County, which split to form Cumberland County. After that, it was under the governance of Bedford County until, in 1773, another division put it in Westmoreland County. Finally, on December 18, 1788, Plum Township, including what is presently Monroeville, became one of the seven original townships of Allegheny County, which had been formed from portions of Westmoreland and Washington Counties in 1786.

At the April 1807 township session, a number of inhabitants from the upper end of Plum Township petitioned for a division by a line running east from where Frankstown Road entered the township on west to facilitate the formation of companies during a new apportionment of militia. At the August 1808 session, a counter-petition was filed, but the commissioners reported that a division at that time was "improper and unnecessary." The idea to divide the township did not surface again for forty years.

Another petition was filed at the June 1847 session, stating that the township was thirteen miles long and six miles wide, that places for election were remote for many residents and that the identity of interest that *should* exist among people of the same township did not. On March 4, 1849, by court decree, Plum Township was divided by a line "beginning where the Frankstown Road crosses the division line of Wilkins Township and said Township [Plum], and following said road by its courses and distances until it strikes the division line of Westmoreland County."

The southern division was called Patton Township, named for a well-known jurist, Judge Patton. A century later, the Monroeville of today would emerge from within the borders of that township. After industry developed and railroads arrived, the sections of Patton Township in the Turtle Creek Valley rapidly developed into small towns and seceded.

In 1892, Turtle Creek Borough was formed from parts of Patton and Wilkins Townships. Just two years later, a charter was granted to form Pitcairn Borough from the southern end of Patton Township. As the adjacent industrial boroughs grew and thrived with commercial, industrial and residential properties, Patton Township remained a rural farming community.

In 1950, three petitions circulated to annex additional parts and parcels of what remained of the original Patton Township. Turtle Creek wanted an adjoining tract. Wilmerding wanted Mellon Plan at the southern end of the

From Frontier to Boomtown

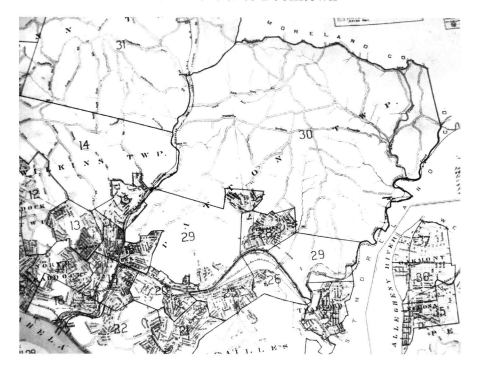

This 1915 map shows Patton Township after land grabs by Turtle Creek, Pitcairn and Wilmerding Boroughs. *Map from plat of G.M. Hopkins Co., Philadelphia.*

township. Pitcairn wanted land between the borough line and the township's Jordan School. And even Trafford Borough officials had an eye on Patton Township land adjacent to Westinghouse plant.

With neighboring boroughs chomping at the bit to acquire choice development areas, Patton Township had no choice but to consider incorporating as a borough, a more complex governmental form that could prevent future land grabs and better serve the growing community. With a ninety-day time limit, a nonpartisan civic league began a drive to garner support for borough incorporation. They went door to door, night after night, to explain the issue to the residents, obtaining 1,800 signatures from 51 percent of property owners, enough to seek incorporation as Monroeville Borough in 1951.

So how did the name of a "straggling hamlet" end up being the name for the new borough? On a cold, rainy night in November 1950, some fifteen residents met and chose Monroeville because many maps already employed that name.

Monroeville Borough 'Born' As Old Patton Twp. 'Dies'

Court Signs Order Freeing Chopped-Up Community from Raids by Its Neighbors

Patton Twp. has thrown off the cares and troubles of 100 years to become the new Borough of Monroeville.

Judge Henry X. O'Brien signed the order yesterday in Quarter Sessions Court, freeing the chopped-up community of any further raids by its neighbors.

The new borough no longer will be the easy target it was as a township. What's more it will be able to set up a planning commission to chart future growth.

Lost 10 Areas

At least 10 sections were carved out of the original Patton area down through the years—including what are now the Boroughs of Turtle Creek, Wilmerding, Trafford and Pitcairn.

The 1937 Annexation Act, which made it easy to transfer land from a township to an adjoining municipality (80 per cent vote of property owners and voters), was the final blow.

Aroused by a series of "land-grabs" that have disrupted communities throughout Allegheny County, residents organized the Civic League of Patton Twp.

1800 Sign Petition

A petition, signed by 1800 property owners, was carried into court by Attorney Harry S. Kalson last Dec. 19.

The court's approval yesterday climaxed the drive.

The new borough has nearly 20 square miles, 7721 residents and an assessment of $7 million. The latter is nearly double its 1940 valuation.

Building Boom Under Way

With the Western extension of the Turnpike coming through this district a building boom is on and the growth is expected to continue.

The present supervisors will continue in office until the next election.

Patton Township got a new name and new form of government in 1951, from unidentified newspaper clipping.

The story of the evolution of Monroeville government might have ended there, except that commercial and residential development continued, creating a more cosmopolitan environment and bringing along the accompanying problems. On May 21, 1974, the citizens approved a Home Rule Charter that went into effect on January 1, 1976, giving power to the citizens of Monroeville to control their affairs rather than the state borough code.

Today, as in early times, Monroeville still has its squirrels and deer roaming the remaining wooded areas. Food is plentiful—not in the woods

From Frontier to Boomtown

and creeks, but at the local supermarkets. Hiking trails wind through local parks, including one that made history.

A Trail through the Woods

Dry brown leaves crunched beneath the feet of British brigadier general John Forbes's troops, and their collective breath formed cloudlets in the frigid air as they cut a trail through the virginal woods near present-day Monroeville in November 1758, on their march to capture Fort Duquesne from the French.

Three years before, British general Edward Braddock had been defeated before he ever reached the fort at what is now Pittsburgh's Golden Triangle, where the Allegheny and Monongahela Rivers merge to form the Ohio. The French and their Indian allies had mortally wounded Braddock and killed or injured about nine hundred of his men just a little more than a mile from the present border of Monroeville. Braddock's first attempt to capture Fort Duquesne in 1754 had also failed with a humiliating defeat at Fort Necessity, near Uniontown, Pennsylvania.

After Braddock's Defeat, the British army retreated from the wilderness frontier, leaving the area vulnerable to roving Indian war parties that burned homes, destroyed crops and seized inhabitants who lacked adequate guns and ammunition with which to protect themselves from attacks. The settlers appealed for help, but instead the provincial assembly fought with the governor about which of them should shoulder the military costs of protecting the pioneers.

In the spring of 1758, the new British prime minister (secretary of state), William Pitt, led an initiative designed by British officials to defeat both the French and their Indian allies once and for all. Forbes, who had been educated as a physician but chose the life of a soldier instead, devised the plan to cut a road across Pennsylvania's mountains, establishing forts along the way as defensive posts should the army encounter trouble. American Indians aligned with the English called him "Head of Iron"—if only the same could have been said about the rest of his constitution.

Forbes suffered from an intestinal disorder that put him out of commission for weeks at a time. That left the second-in-command Colonel Henry Bouquet, a Swiss mercenary commissioned in the Royal American Regiment, to lead the advance force over the mountains as Forbes struggled to move the main army forward. As his illness delayed progress, the general worried that winter would arrive before his troops could seize the fort and end the French and Indian War.

It was already early November by the time the seven-thousand-strong army reached Fort Ligonier to the east. The men were a hearty bunch, made up of Scottish troops from the Seventy-seventh Regiment of Foot, known as Montgomery's Highlanders; four companies of the Sixtieth Regiment, known as the Royal Americans, which included Germans living in Pennsylvania; and ranks of provincial troops that included Swedes, Finns, Dutch, Poles and Irish. The army had teamsters to drive the wagons, herdsmen to tend to the livestock and women to handle the cooking and laundry. But despite their stalwartness, many soldiers lacked shoes, stockings, coats and adequate provisions for the approaching winter chill.

Forbes had decided to wait at Fort Ligonier until spring to proceed but changed his mind after learning from an English deserter captured during a skirmish that the French were low on provisions and that many soldiers had fled down the Ohio River to winter quarters. News also reached the fort that diplomatic efforts had persuaded the Indians to abandon their French allies. This information convinced Forbes to push his army forward to Fort Duquesne before winter.

The general broke his army into three brigades commanded by Bouquet, Lieutenant Colonel Archibald Montgomery and Colonel George Washington, who had served under Braddock during the two previous attempts to capture Fort Duquesne. Leaving from Fort Ligonier, each brigade traveled on a separate marching route through the wilderness with enough distance between them to avoid a complete ambush but close enough to come to one another's aid. The memories of having musket balls rip through his hat and coat at the Battle of the Monongahela with Braddock must have entered Washington's mind as he began to lead his 1,600 men toward the Ohio.

They advanced rapidly through mature forest, not always taking the best route through the hilly terrain. Washington had wagons and artillery pieces with him, along with Forbes, who was carried on a sling between two horses. As they entered present-day Allegheny County, where Pierson Run empties into Abers Creek along the Monroeville–Plum Borough border, the soldiers only had to fell trees to make the trail because the leaves formed a canopy that prevented undergrowth.

On November 24, Forbes and his troops were a day's march from their objective. That night, as Washington camped near what is now the Boyce Park ball field and Bouquet's brigade spent the night near the present intersection of Old Frankstown and Davidson Roads, Indian scouts arrived at the British camp to report seeing smoke coming from the direction of Fort Duquesne.

A troop dispatched to the riverfront discovered that the French had destroyed all that they could not take with them and then burned the fort

From Frontier to Boomtown

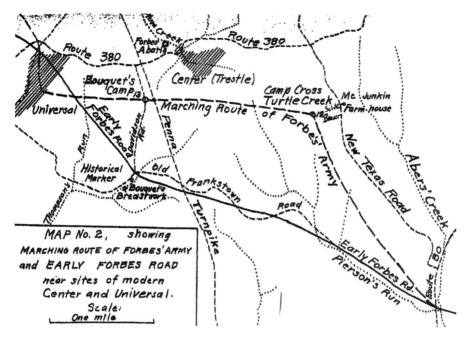

This map depicts the paths of Forbes Trail, Forbes Road and Old Frankstown Road. *Courtesy Allegheny Foothills Historical Society.*

to the ground. For Washington, the losses at Fort Necessity and Braddock's Defeat faded, and the third time became the charm as he saw the Union Jack planted at the site, a sign of victory for the British. Forbes, carried by stretcher to view the charred ruins, penned a letter to William Pitt, saying: "I have used the freedom of giving your name to Fort Duquesne, as I hope it was in some measure the being actuated by your spirits that now makes us Masters of the Place."

After the British secured Fort Pitt, they returned and fixed the route of what would become known as Forbes Road and later form the route of Old Frankstown Road, about a mile from the original marching path of George Washington. The only reason any trace of the marching path remains in the twenty-first century is because farmers continued to use it for about fifty years after Washington came through.

According to a map made by John Potts, a cartographer who traveled with Forbes, the present-day Outer Trail and Carpenter Trail in Boyce Park follow Washington's marching trail. The late Eleanor Carpenter Broome grew up in Carpenter Log House, built in 1822 and inhabited by her family until 1958, which still stands in the park today. In an oral history, she

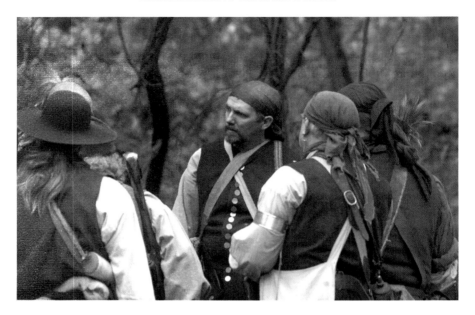

Reenactors reconstructed George Washington's trail during the 250th commemoration of the French and Indian War. *Photo by Lillian DeDomenic, Gateway Associated Photographers.*

recalled, "My father told me that the old Forbes Road followed Pierson Run to just beyond our house, where it crossed the small creek near the house and headed up the hill."

The night before capturing the fort, Washington spent the night at what he referred to as Camp Cross Turtle Creek. Although local historians knew the location of Bouquet's camp, the exact location of Washington's camp remained somewhat a mystery until 2005, when Gary Rogers and Tom Whanger of the Allegheny Foothills Historical Society used a Global Positioning System, topographical maps, maps of early Plum and journals written by both Forbes and Bouquet to approximate the trail's location from the Carpenter Log House.

From the present-day intersection of Pierson Run and Spring Miller Roads, Washington's men marched up the hill and along the ridge visible from Carpenter Log House, parallel to New Texas Road. There were historical references to the camp's location as a quarter-mile due southwest of the McJunkin farmhouse, located on New Texas Road in Plum Borough. Using those descriptions, Rogers and Whanger estimated the camp's position as having been located somewhere near the Boyce Park softball fields and tennis courts, located off New Texas Road.

From Frontier to Boomtown

During the Pittsburgh 250 celebration in 2008, Boyce Park was transformed into a scene from the French and Indian War. During the Washington's Encampment event, visitors watched as reenactors cut the marching path once again.

Good Old Log Cabins

According to local lore, some of the earliest log cabins built in what is now Monroeville were destroyed by American Indians who tried to discourage settlement in the area. The first home of the Captain Robert Johnston family was burned to the ground. Indians destroyed another one in the vicinity of Monroeville Boulevard and Jamison Lane no sooner than it had been built, and a second cabin was soon constructed nearby.

About 1777, a family that lived on Thompson Run, three miles from Turtle Creek, was murdered by Indians. Another family was murdered at Dirty Camp in the area that would become Patton Township.

Some of the early inhabitants of the area were craftsmen—gunsmiths, wheelwrights, weavers, blacksmiths and stonemasons. They were also farmers and hunters, growing their own food and searching for game just to survive. The hilly, wooded terrain in western Pennsylvania made farming difficult. That did not dissuade the hardworking, God-fearing Scotch-Irish who were the first settlers in the area.

In 1786, the *Pittsburgh Gazette*, the area's first newspaper, noted that there were 1,500 people in the Pittsburgh area, including the area that would become Monroeville. It was a hard, simple life, with social activities limited to weddings, funerals, sporadic church services and barn or cabin raisings.

When people first arrived in the area, they lived in tents or lean-tos until a cabin could be built. Men felled the trees and young boys removed the branches. Because nails were scarce, notches were made in the rough logs so each successive log could fit into the groove of the one below it. By the time the early residents settled on their land grants, the round, unfinished logs were being replaced by square, hand-hewn logs that fit tighter as better weatherproofing. The roof was made of bark or wooden shingles.

A mixture of mud, clay and straw filled the chinks between the logs. Other men gathered stones for the fireplace, made large enough to accommodate the huge iron pot in which meals were cooked. Neighboring women joined together to prepare the meals as girls tended to the young ones.

The cabins were mostly one-room structures, barely twenty feet square, though some had a loft accessible by ladder that served as sleeping quarters

for children. With as many as six to ten children in a family, space was tight. Fires were kept stoked at all times to provide for cooking and warmth during the harsh winters. Chimneys were constructed of timber and plastered with a mixture of clay, mud and straw, posing a constant hazard. For that reason, pails of water had to be kept close by to extinguish fires.

The furniture in the dirt-floored houses often consisted of nothing more than a crude table and benches that sometimes doubled as beds. Pioneer families used animal skins as bedclothes to keep warm.

The pioneers sought locations with a spring, not only as a source of water, but also to provide an early form of refrigeration. A crude structure was built around the spring and a trough or basin made to catch the water.

As the pioneers settled, they often built additions to their log cabins or replaced them with sturdy log homes to better accommodate the needs of their families. Some of these early cabins have survived two centuries and are used as homes today.

A seven-room log house on Wallace Drive, said to be the original home of George Lang, a Revolutionary War soldier, and his family, dates to at least 1790, possibly earlier. In the early 1800s, the house served as a coach stop and livery stable for stagecoaches headed east from Pittsburgh when Wallace Drive was called Old Stagecoach Road. The top floor had two bedrooms for overnight guests. Now modernized, there are few traces that show that it was a log house.

The Johnston-McCully House was built about 1790 on what is now James Street by John McCully, a patriarch of an early pioneer family. The house passed to his granddaughter, Sarah McCully, who married William Johnston Jr. in 1854. At their wedding, held on the front porch of the house, someone fired a few shots, according to family lore, and those lead bullets are still embedded in the log walls.

In 1982, William J. Johnson bought the house and began a complete restoration. While stripping away the interior walls, he found a cooking fireplace with utensils, bottles and other artifacts. He also found a well and a hidden tunnel about twenty feet long that ran beneath the house to the well, perhaps an underground sanctuary sometimes found in frontier houses in case of Indian attacks.

Haymaker House, also known as the Maxwell House, is located on Northwestern Drive. Built sometime about 1800, it is said to be the original home of the William N. Haymaker, whose son, John C. Haymaker, became a prominent Patton Township judge and assistant district attorney in Pittsburgh in 1887. After staying in the family for many decades, it had several owners before Curtis and Lou Ann Brooks, who completed a major renovation in 1998.

From Frontier to Boomtown

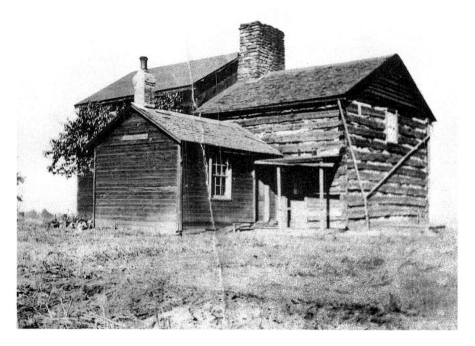

The McCully-Johnston House on James Street as it stood in the 1880s. *Courtesy Monroeville Historical Society.*

The Graham House, a two-story log house built about 1815, sits tucked in hillside seclusion along Old Ramsey Road. Henry Small first owned the property, according to records from the 1780s. The property changed hands twice before being purchased by the Grahams, whose family farm was located in the northeast portion of Patton Township for a good part of the nineteenth century. After changing hands again, it was bought in 1942 by Milan and Catherine Drakulic. By that time, the house was in need of major repairs, and it lacked utilities, indoor plumbing and a modern furnace. Richard and Mary Salnick bought the house in 1975 and undertook a major restoration.

The McCully Log House, built in the early 1800s, was slated for demolition in 1992 when Monroeville Historical Society came to the rescue. In 1810, John McCully purchased land from the family of Martha Miers, one of the earliest settlers. McCully built his house about a block away from the log house owned by his brother James, mentioned above. Over the years, there were a number of owners, additions and changes in the appearance, including a modern siding covering the logs. The structure became dilapidated and was finally abandoned.

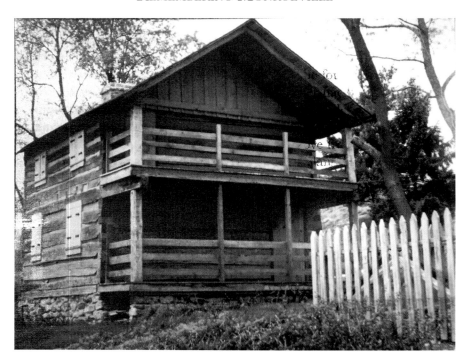

To save it from demolition, McCully House was reconstructed next to the McGinley House. *Photo by Lillian DeDomenic, Gateway Associated Photographers.*

 The Municipality of Monroeville and the historical society raised funds to restore the house. Volunteers removed the twentieth-century façade, dismantled the house, tagged its components and moved it from its location on Queen Drive. Over the next three years, it was reassembled at a site next to the historic McGinley House on McGinley Drive. The ground floor of the two-story house served as a sitting room and kitchen, while the upstairs was the family's bedroom. It is unique in having a double-decker front porch with large logs cantilevered out from the second floor to support the porch. McCully House and McGinley House are now under the care of the historical society.

 McGinley House, built in 1830, is the oldest existing stone house in Monroeville, typical of the western Pennsylvania stone farmhouses. A split-level house constructed of twenty-four-inch-thick fieldstone, it has an older two-story section and a raised one-story kitchen wing added at a later date. John McClintock, son of owner Joseph McClintock, was a stonemason and farmer who built the house. One of John's daughters, Margaret, married Isaac McGinley, and the farm remained in the family for a century. Isaac's

From Frontier to Boomtown

son, Joseph, sold the eighty-seven-acre farm in 1932 to Max Miller, a Pittsburgh real estate businessman.

By that time, the house had caved in, but the foundation was intact and the stones still remained on the property. Miller had the house rebuilt and modernized. Miller's wife, Elizabeth Solomon Miller, grew up on a farm and wanted to spend her summers there. Eventually, she wanted to live there year-round, so she convinced her family to move from their farm in Turtle Creek to Monroeville and help work the Miller land.

In 1967, Westinghouse Electric Corp. bought the former McGinley farm for its nuclear research facility. At the urging of Councilman James Mirro, Westinghouse donated the house to the Municipality of Monroeville in 1969, which designated Monroeville Historical Society as caretaker. Both McGinley and McCully Houses preserve slices of life from the nineteenth century. Several other farmhouses from that era are still standing within municipal borders.

One more log house remains in Monroeville—the former Rising Sun Inn on Northern Pike.

Stagecoach a'Comin'

In many ways, the Monroeville of today can thank the Northern Turnpike for putting it on the map at all.

In the early 1800s, the area was still part of Plum Township, a wooded, hilly area with some patches of emerald green farmland between the trees. The farms were pretty much self-sufficient, and the main dirt roads in the area were mostly Indian trails that had been widened to accommodate packhorses.

When General "Mad" Anthony Wayne led a crushing defeat of the eastern American Indian nations at Fallen Timber in 1794, he made western Pennsylvania safe for travel. Brave-hearted people from the East Coast cities loaded their possessions into wagons or onto trains of packhorses and headed for the western frontier. Along with traders and soldiers, they followed the narrow Indian trails through the rough terrain of the Allegheny Mountains into the valleys of the Pittsburgh area. At various points, traders constructed crude trading posts that evolved into many small rural villages along what is today Route 22 in that region.

Using axes and torches, road crews made their way through the thick forests, following the narrow Indian paths and blazing trails wide enough to handle the stagecoaches and wagons in the late 1700s. But the quality of

the roads was poor. Each year, the state treasury had to allot money to clear the underbrush that crept back onto the dirt roads. In 1800, commonwealth officials decided that the best way to have good roads at a reasonable cost was to create a toll road to facilitate travel between Philadelphia to the east and Pittsburgh to the west.

An Indian trail became the path of choice when plans were laid for the Northern Turnpike, which was completed in its entirety in 1807. Northern Pike once climbed into and out of the Thompson Run Valley just north of Hall Station, which came later. Like many Indian paths, it followed mostly level ridges and stayed away from flood areas, crossing water only at the narrowest points.

Abraham Taylor was among the entrepreneurs who left Philadelphia to open up inns along the new route. He settled thirteen miles east of Pittsburgh on a ridge in Plum Township, purchasing ten acres for the inn and a livery stable across the road. The place where he settled and built his inn didn't even exist on maps, although there were farms in the area.

Taylor's inn was constructed of hand-hewn logs and hardwood floors held together with wooden pegs. When the stagecoach line opened in 1802, drivers heading east in the early morning noticed that they were riding into the blazing sun—thus the inn became known as the Rising Sun.

The fifty-six-hour trip between Pennsylvania's two largest cities cost twenty dollars. Travel took place around the clock. Every ten to fifteen miles, the coaches stopped at relay points like Taylor's Rising Sun Inn to change horses. At mealtime, drivers and passengers disembarked for a twenty-five-minute break. When it wasn't mealtime, the stop lasted no more than five minutes, only enough time to hitch up a new team of horses and drop off or pick up mail. Passengers changed coaches about every fifty miles. In the mountain regions, the stagecoaches were sturdy and utilitarian. But for the final leg to the city, the coaches were lighter and more elegant, and their drivers dressed in a formal tall hat and long coat with tails.

Even today, the approach to Taylor's inn from the west has a rural feel, even though the road runs parallel to busy Business Route 22. With a little imagination, one can almost feel the sway of the wagon as it climbed the steep hills to reach the more level stretch of Northern Turnpike near the inn. In the days of the Northern Pike, as the trotting pace of the horses grew louder in the distance, farmers paused from their work to look up and children ran to the roadside. As the coach neared, the driver sounded a bugle to alert Taylor of their arrival.

In the kitchen, Taylor's wife, Jane Collins Taylor, and their daughter, Sarah, listened for the number of blasts at the end of the bugle melody,

From Frontier to Boomtown

indicating the number of guests who would need to be fed. A fireplace in the cellar was equipped with a cooking crane, so meals may have been prepared there. Outside, grooming boys waited by the entrance, ready to bring a fresh team of horses from the stable and exchange mailbags. The driver paid for using the road in a nearby log house that served as a tollbooth. Within thirty minutes, the guests departed and the clip-clop sound of the horses' hooves grew ever fainter.

Each day, two eastbound and two westbound carriages stopped at the Rising Sun Inn. They weren't the only ones using the road. Mining companies shipped iron ore along the Northern Turnpike to the mills in Pittsburgh. In return, Pittsburgh shipped out saltpeter and cords of wood. By 1810, the hamlet included two blacksmith shops and two general stores at which men met to share news. Alexander Thompson, a farmer who lived along the Northern Turnpike, estimated that 5,800 wagons passed his residence between 1800 and 1815.

In 1816, a Scottish merchant, John McAdam, was doing business in New York and Philadelphia. In talking with some associates who traveled the Northern Turnpike, he learned of their dissatisfaction with the road's condition—uneven and dusty in the dry summer and a muddy quagmire after a rain.

Upon his return to Scotland, McAdam created a gooey paste of finely crushed gravel and tar. Macadam, as it became known, was the forerunner of modern pavement. By 1818, the stagecoach route had become one of the nation's first paved roads, a gray ribbon among the green of the woods and fields that revolutionized travel by cutting down the hours needed to make the cross-state journey. By 1828, the state had more than 3,100 miles of roadway, with towns springing up overnight along their routes.

However, the area around Rising Sun Inn remained quiet farmland, untouched by the growing population. Between 1810 and 1825, only four families moved into the region.

At one point, it appeared that the newly constructed canals across Pennsylvania would pull traffic from the Northern Turnpike. The canals drastically cut the costs of shipping freight, but at the same time, the Pennsylvania Railroad began laying tracks to connect the state. The canal companies had hoped to shorten shipping times using a combination of canals and trains. When schedules could not be coordinated, frustrated canal shareholders sold out to the Pennsylvania Railroad, taking a $17.5 million loss. Still, the Northern Turnpike survived.

When the Pennsylvania Railroad opened service from Philadelphia to Pittsburgh on November 29, 1852, the Northern Turnpike's fate was sealed.

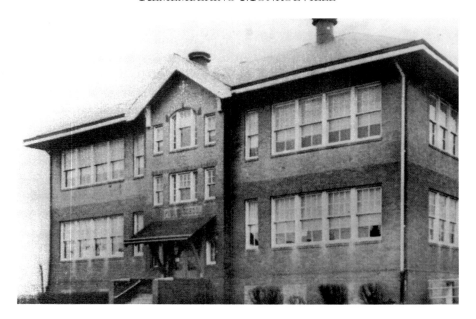

Monroeville School was built in 1911 on Northern Pike. *Courtesy Monroeville Historical Society.*

Without the stagecoach and shipping tolls, the road fell into disrepair. Businesses began to slowly disappear. In the days before his death at age sixty-three in 1857, Taylor was tired and frustrated.

Jane Collins Taylor and daughter Sarah continued to live at Rising Sun Inn but turned to growing vegetables to sell at market. One of their customers was George Washington Warner, twenty-three, a grocer from Allegheny City, now Pittsburgh's North Side. After a number of visits, he and Sarah fell in love, married and made their home in the Rising Sun Inn.

Tragically, Sarah died at a young age after having three babies in four years, leaving Warner a widower for twenty years before he married Nancy King McElroy. Together, they had six children, and Warner lived at the inn until his death at age eighty-eight in 1933. One of his sons, Horace "Hook" Warner, served as president of the Monroeville Area Industrial Development Authority and became the first president of the Monroeville Area Chamber of Commerce in 1952.

In 1908, the state made improvements to Northern Pike to meet the increased traffic demands from automobiles and trucks. Within a few decades, though, the roadway would be superseded by a new road, William Penn Highway, which utilized portions of the old toll road as it passed through Monroeville.

From Frontier to Boomtown

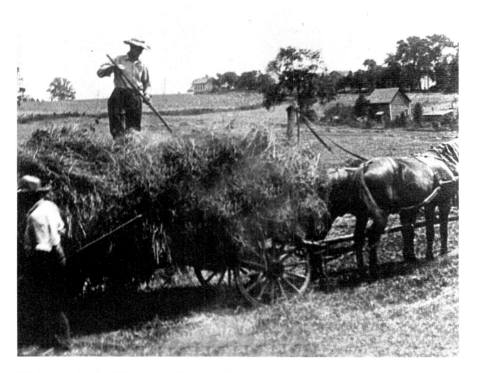

Workers on the Duff Farm along Northern Pike made hay in the early 1900s. *Courtesy Monroeville Historical Society.*

After the stagecoaches were gone, the Rising Sun's stable became an auto repair garage. Those tearing it down found a hidden treasure—a stagecoach that apparently had been forgotten after its last run.

The Rising Sun Inn still stands today as a doctor's office, though its logs are covered by blue siding, and a bay window replaces the front door. Leonora Warner Reese, a descendant, sold the house in 1976 for $100,000 to Dr. Douglas McDonald.

Two segments of Northern Pike are still in use in Monroeville. If one stands at the former Rising Star Inn and looks southeastward across Route 22, the path of Northern Pike through what was once the hamlet of Monroeville is

clearly evident, even though the one portion has been renamed Monroeville Boulevard and a four-lane highway now bisects it.

A Tale of Two Churches

Sitting alone atop a high knoll as an island in a sea of commercial development, Old Stone Church is Monroeville's most recognizable historic landmark.

Located at the busy intersection of Stroschein Road and Monroeville Boulevard, the former home of Cross Roads Presbyterian Church has an interesting history, but it was not the first church. That place in history belongs to Bethel United Presbyterian Church.

It's little wonder that the earliest churches in the area were Presbyterian. The first church judicatory established on American soil was the Presbytery. In 1706, 7 ministers came from Scotland and the north of Ireland, gathered in Philadelphia and established the Presbytery of Philadelphia, which included all the churches in the country. By 1789, the General Assembly became the highest court of Presbyterianism, overseeing 16 Presbyteries with 177 ministers, 431 churches and 4 synods.

After Chartiers Associate Presbytery in Buffalo, Pennsylvania, approved Bethel United Presbyterian Church's petition to establish, the church installed its first minister, Ebenezer Henderson, on December 30, 1801.

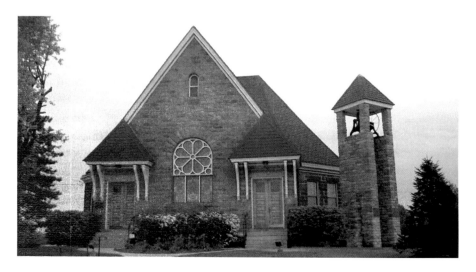

Cross Roads Presbyterian Church, now Old Stone Church, Monroeville's best-known historic landmark. *Photo by Colleen Eliese Gribbin.*

From Frontier to Boomtown

Services were held in homes and outdoors by traveling ministers prior to that time, but no records exist before the church was officially established. A log cabin was built on land owned by Robert Clugston to serve as a place of worship in 1803.

In 1804, changes left Bethel without a pastor for sixteen years. Between 1820 and 1834, several families left Bethel to form Unity United Presbyterian Church in a part of Plum Township that is now Plum Borough. When the Pennsylvania Railroad was built, more members left the mother church to form new churches in Turtle Creek, Stewart Station (now Level Green in Penn Township), Logans Ferry and Murrysville. The congregation survived, only to have the church destroyed by fire in 1863.

The membership met in a schoolhouse until a new church was built in 1865 in the vicinity of what is now Seco Road in Monroeville Industrial Park. The new church was a one-story, square building with double doors and several stained-glass windows. One potbellied stove in each corner provided heat. To provide light, a large chandelier hung from the ceiling with several old lamps on it. Later, when gas was piped in, those fixtures were replaced by gas stoves and gaslights.

In 1921, the ground surrounding the church was strip-mined. The church building, left alone in a ravaged field, was removed the following year. The congregation worshipped with Cross Roads Presbyterian Church until a new building was dedicated in 1925 on Beatty Road, near Center Road. Many of the stained-glass windows from the old building were used in the new church, a Gothic Revival–style brick structure with a wide, single-gable roof and square corner tower. An addition to the existing structure built in 1961–62 provided a larger sanctuary and educational wing.

As Bethel weathered the winds of change, Cross Roads was making some history of its own. Before Cross Roads Church organized, its congregation was affiliated with Beulah Presbyterian Church, one of the area's first churches. Charles Carothers, a well-to-do farmer and ruling elder at Beulah, decided that he wanted a place of worship closer to home. He and his son, Robert, also a Beulah elder, assisted with organizing the new church and provided generous support for the church and pastor. Andrew Mellon, who later became U.S. secretary of the treasury, was elected as one of the first elders. When he moved from the community, he retained his membership.

The first Cross Roads church, fifty square feet in size, was built by its members in 1835 for $1,500 in anticipation of being approved as a Presbyterian Church. The members had petitioned the Blairsville

Presbytery in 1834 to allow them to form their own congregation, but it took three times before their wish was granted two years later. Opposition from neighboring churches had delayed the approval. Stone for the foundation was obtained from various farms around the church property, and adjacent property owners were persuaded to sell small parcels at the edge of their borders to trustees of the new organization. The church had forty-seven charter members.

When completed, the new church was essentially a rural meetinghouse with four doors. The seats were laid out in irregular groups—the side sections faced the middle, and the middle section faced the high pulpit placed at one side. The church had no heat, so in cold weather families would bring hot bricks from home and huddle around them, hoping that the sermon would end before the heat did. Later, potbellied stoves were installed in the corners of the room. According to a history written in 1876, most members owned or rented their own pews.

At the beginning, however, the church wasn't known as Cross Roads. A plan to share ministerial services with Plum Creek Church resulted in the name South Branch of Plum Creek. Because of financial issues, it was often difficult for small congregations to secure a full-time minister. A church record showed that for sixty-five dollars, pastoral services could be secured for thirteen Sabbaths at a cost of five dollars each, plus free board for the pastor and his horse. Pastors came and went frequently.

On December 18, 1866, the Reverend Robert Carothers, grandson of the first elder, Charles Carothers, was installed as pastor of Cross Roads and served until 1878.

The Cross Roads treasurer's book from 1895 reveals some interesting figures. One week's collection in April was $0.75, while by December that year it grew to $2.77. One can only wonder if the spring collection was lower because farmers were tending to the fields, or if more members attended church during Advent in December. Six gallons of oil cost $0.90 and bolts for the hitching post cost $0.70, almost one week's offerings. The sexton's salary for three months was $11.25.

By 1896, the first church was beyond repair, so the building now known as Old Stone Church was constructed. The new church was described as a simplified version of Richardsonian Romanesque style with a primitive western Pennsylvania flair. Stone from the first church was used for the new structure. The remaining stone came from the local Snodgrass quarry. The basement walls of the first structure were still in good condition but of a different size than the new design. In three areas, the builders were able to make use of the earlier foundation.

From Frontier to Boomtown

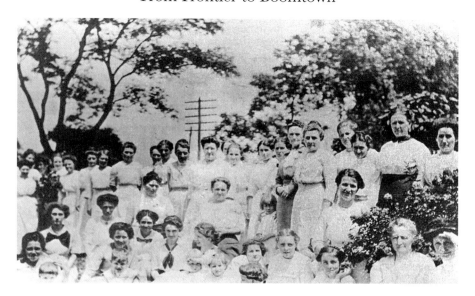

The women of Cross Roads Presbyterian Church gathered for this photograph in 1915. *Courtesy Monroeville Historical Society.*

When formally dedicated in 1897, the church had heating but no electricity or indoor plumbing. Subscriptions were taken to pay the debt on the new church. According to records, Andrew Mellon—son of Thomas Mellon and grandson of the Andrew Mellon who served as one of the church's first elders—was the largest individual contributor. Most donations were between $5 and $10 but Mellon, whose father was a founder of Mellon National Bank, gave $100.

The carriage shed for Old Stone Church was a long, low building enclosed on three sides, with a low-slanted roof and mangers located along the enclosed side. The mangers were filled with hay for the horses to munch on while the owners attended worship. In good weather, families used their showier horses. In winter, it wasn't unusual to see teams hitched to a sled filled with straw, where occupants huddled under blankets to keep warm.

The congregation continued to grow with Monroeville and needed a new home to accommodate its membership by the early 1950s. For a decade, the church met in a building along Route 48, later sold to Holiday Inn, which renovated the structure as a hotel that serves guests to this day. The church moved to its new home on Haymaker Road in 1967, where it remains.

The old church on the knoll was purchased by the Church of Christ, which used it until 1969. Fearful that the landmark church might be demolished,

longtime resident T.M. Sylves and his daughter, Sarah Sylves Thompson, bought the structure and deeded it to the Borough of Monroeville on December 29, 1969. They stipulated that the building would be owned by the municipality but that the stewardship would be the responsibility of the Monroeville Historical Society.

Today, the church is often used for weddings and is where the community comes together for an annual Christmas celebration.

PART II
SETTLING INTO THE RURAL LIFE

The Widow Miers

The William Penn family had secured an agreement with the Ohio Valley Indians in which the Native Americans transferred all lands they possessed west of the Allegheny Mountains into British hands. Before the treaty of Fort Stanwix in 1768 officially ended the French and Indian War, it was illegal to file land claims or settle within the western portion of Pennsylvania beyond the Appalachian Mountains. A proclamation declared in 1758 by Governor Denny and the Pennsylvania Provincial Council, though, did not stop traders, merchants or squatters from settling in the region.

The early frontiersman John Fraser and his wife, Nellie McLain Fraser, were the first settlers in the Turtle Creek Valley. After arriving in America following the Scottish Rebellion in 1745, Fraser was granted a license by the Pennsylvania colonial government to trade with the Indians.

He built his first cabin near French Creek on the Allegheny River but had to flee that residence, settling next in the valley formed by Turtle Creek just before the stream empties into the Monongahela River. Many historians place the location of his cabin underneath the landmark George Westinghouse Bridge. He had to flee the cabin after Braddock's Defeat but was the first in line to secure a land grant of three hundred acres in the area east of Pittsburgh, in what is now Braddock.

The second person was Martha Miers. While Fraser's property was located just a few miles west of the present-day Monroeville border, Miers was unquestionably the first landholder in what would become Patton Township. The 350 acres she received was referred to as "the Widow's Dower" as it was titled to her deceased husband Eli (Eliezer) Miers.

The spelling of the surname appears in several forms in historical documents. Some local historians believe the misspelling comes from the

fact that those who recorded the original name as Myers or Meyers were English language users and spelled it that way. After investigating the family's genealogy, it appears that the original spelling was Miers, which was German in origin, though Mires also appears as an alternate spelling.

Martha, born Marte Braun in 1715, was a fifty-four-year-old widow when she came to settle in the Turtle Creek Valley. She brought her children—Eleazer, James, Agnes and Martha—along with four grandchildren, with her when the family left their home in Bedford, Pennsylvania.

Since John Fraser may also have come from Bedford, it is quite possible that the Widow Miers learned of the land available in the Turtle Creek Valley from him. Fraser had begun a land speculating business, and as an agent, he was active in finding buyers for land in western Pennsylvania.

The Widow Miers purchased the 369-acre land tract in April 1769 and built a log cabin on a hill overlooking Turtle Creek. Quite possibly she employed men from Fort Pitt to help with the construction, as they often were hired out to build settlers' cabins. The builders used their earnings to buy land and move their own families into the area.

The cabin was large enough to accommodate guests and became a local landmark in the early western frontier wilderness days of Pennsylvania. Recognizing a business opportunity, Miers opened an inn at the corner of what would become Church Street and Penn Avenue in Turtle Creek to house weary travelers as they made their way westward. Pioneers, soldiers, express riders, Indian traders, itinerant parsons and land speculators, as well as the man who would become the new country's first president, found board and lodging with the Widow Miers.

Colonel George Washington was among the early guests, likely partaking of the wine and sumptuous repasts for which the inn was famous. The journal of his tour of the area in November 1770 says: "23rd. After settling with the Indians and the people that attended me down the river, and defraying sundry expenses accruing at Pittsburgh, I set off on my return home; and after dining at the Widow Miers' on Turtle Creek, reached Mr. John Stephenson's in the night."

By 1780, Wayside Inn became a regular stop for stagecoaches traveling local toll roads and turnpikes. When the first national road was built in 1792 between Philadelphia and Pittsburgh, it passed in front of the inn. Stables and a corral were built across the street.

On an average week, four stagecoaches passed through and the inn became a regular stop in the relay station system when wagoners with goods and merchandise headed to Pittsburgh along Greensburg Pike, a toll road that came through the Turtle Creek Valley. When a coach or wagon crested

From Frontier to Boomtown

the top of Greensburg Pike hill, the driver sounded the horn letting the Mierses know how many guests to expect based on the number of blasts.

The inn's rooms were large and square with low ceilings and old-fashioned fireplaces to keep the place warm. Pewter ware and earthen cups adorned the walls behind the bar.

Several articles were written about Miers's inn, including one in 1785 by Samuel Vaughn, "Made by Samuel Vaughn from his Minutes, Stage to Stage, on a Tour to Fort Pitt." In it, he mentions: "Dined at Mrs. Miers, nearly 80 years old (bent almost double), yet active and furnished a good dinner. 12 miles." Evidently, the hard work had taken its toll on the widow, as she was only seventy at the time of the story. Miers died at the age of ninety after operating the inn for nearly forty years. In her lifetime, she witnessed the birth of her nation, state, county and of Plum Township, part of which would eventually become Patton Township.

Her oldest son, Eleazer, was a Revolutionary War soldier. For his service, the United States government granted him three hundred acres in present-

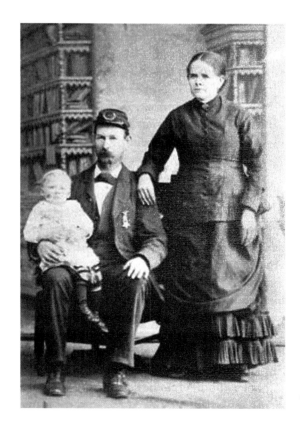

Daniel and Catherine McMunn were descendants of Martha Miers, the first landowner. *Courtesy Monroeville Historical Society.*

Remembering Monroeville

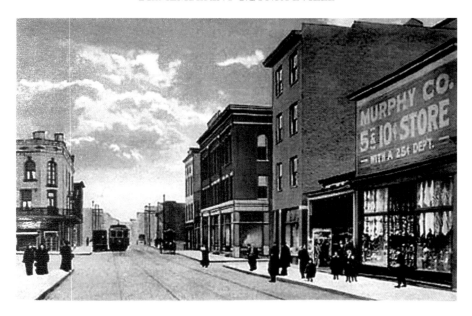

An old postcard view of the Turtle Creek business district in the early 1900s, from the corner on which Martha Miers once ran the Wayside Inn.

day Monroeville. Her children, James and Agnes, and their spouses owned property in what is now Turtle Creek. Martha and her husband moved to the Harrison City/Trafford area. An old mill just across the line on the border of Patton and Wilkins townships belonged to James Miers, although, again, the spelling of the last name would come into question. In the wall of the mill was a stone marked "James Mires, 1783." The old mill ceased to exist, but the stone was placed in another mill built on the same site.

In 1817, Henry Chalfant purchased the inn, renamed the Broadway Inn in 1832, which he ran with a general store until 1847. After Chalfant, the McMaster and Miller family operated the building as a general store and apartments until 1912. At the end, the logs had been covered with clapboards.

That part of Patton Township had already become Turtle Creek Borough, a bustling business community fed by industrialist George Westinghouse's factory there. H.M. Phelps of the *Pittsburgh Dispatch* wrote in an article dated May 22, 1910 ("Inns of the Revolutionary Days: Taverns Where Weary and Dust Covered Travelers Were Cared For") that the inn itself was "weary" and "weatherbeaten."

Its days of feeding weary travelers were long gone. The building was put to bed in 1912—razed to make way for progress.

From Frontier to Boomtown

The Johnstons: A Homesteading Family

If there is one typical Monroeville family whose generations have spanned the decades since even before the days of Plum Township, it is the Johnstons.

The family originated in Annendale, Devonshire, Scotland, where two of the clan were said to be neighborly with William of Orange, then king of England. He granted them a land tract in Tyrone County, Ireland, about 1695. Two of the sons were among the Scotch-Irish who came to the colonies in the early 1700s and pushed their way across the frontier into western Pennsylvania.

James Johnston, the patriarch of the local family, settled in Loyalhanna Township, Westmoreland County, which at that time was part of Lancaster County. He married Elizabeth Campbell and had four children, including twin sons Robert and William.

In 1778, William Johnston came to the area and purchased a tract of land within two miles of Turtle Creek. He was a Revolutionary War soldier, fought with General "Mad" Anthony Wayne at the capture of Stony Point and was a packhorse commander under General Nathanael Greene in Greene's Carolina campaigns. The road close to his home still bears the family name. His wife, Mary Clugston Johnston, was young when she died in 1796.

His brother, Captain Robert Johnston, was a wagon master in the cavalry for Colonel George Washington. On April 3, 1769, the captain applied for a land grant on Dirty Camp Run, which he obtained on March 3, 1789. His original grant was for 321 acres at a cost of forty-four pounds, four shillings. To become the legal owner, he had to meet certain qualifications, such as residing on the land for a specified number of years, making certain improvements and clearing certain areas. These requirements prevented people from obtaining land and then selling or trading it for undesirable uses.

The first dwelling on the Robert Johnston property was located near the present-day Ivanhoe Apartments on Monroeville Boulevard. The barn and granary were sited at almost the exact location of the entrance. Early settlers like the Johnstons lived in constant fear of Indian raids and fires. The family's fears became reality when their first house was burned down by Indians. The family escaped capture by hiding in a corncrib attached to the house. After such raids, settlers would face the agony of rebuilding their home and gathering food and clothing just to survive.

Robert Johnston traded one hundred acres of his original land to Mr. Snodgrass for a half a cow, meat from nine hogs and enough other food to survive another growing season and harvest time to replenish their stock.

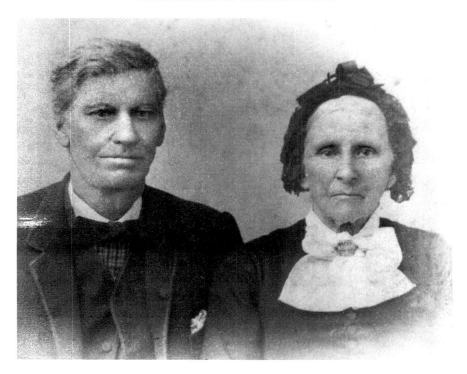

Robert and Martha Johnston, second-generation homesteaders, in the mid-1800s. *Courtesy Monroeville Historical Society.*

The Johnstons lived through those woes, converting their granary to a house that, through additions, eventually grew to fourteen rooms. The floors were eight-inch, tongue-and-grooved oak planks, and the beams were hand hewn. A second house was built across the street in later years.

The Johnstons faced another tragedy in their early years. A child wandered away from the homestead in late fall or early winter and, despite many efforts, could not be found until the next spring. The child was buried at that site on a knoll on the Johnston farm. When his sister-in-law, Mary Clugston Johnston, died, Captain Johnston agreed to have her buried next to the child. In 1800, he dedicated about an acre of that land for a common cemetery as a final resting place for his family and friends. For the next 150 years, the farm and its family reflected the faces of Patton Township, a rural farming community with common folk who had little impact on the outside world.

Robert Johnston's great-great-great-great-grandson, Floyd Johnston, and his sons, Robert and Edward, were the seventh and eighth generations of Johnstons to work the land. Johnston's Dairy Farm was started in 1908 and

From Frontier to Boomtown

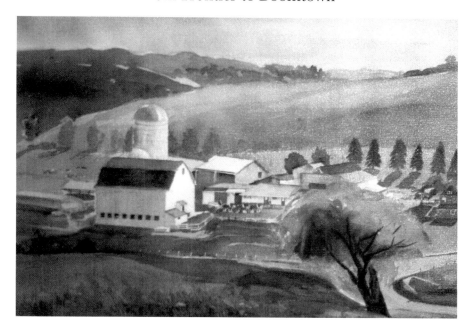

Floyd Johnston, a descendant of one of Monroeville's first residents, painted a view of his farm. *Courtesy Monroeville Historical Society.*

delivered milk to the town folk in Pitcairn. The steady business picked up with the growth of population in the post–World War II years.

After 1961, Floyd did little farming, but he did operate a cash-and-carry dairy store where people took milk in jugs that required a twenty-five-cent deposit. The family's farm wagons, pulled by their team of Clydesdale horses, were welcome fixtures in community parades, a fitting tribute to the past as Captain Johnston was a wagon master in Colonel George Washington's army. But the same things that created more business also helped to kill it. By the 1970s, Johnston's Dairy Farm was a rural oasis penned in by Miracle Mile Shopping Center, apartment complexes and residential dwellings.

The original land grant had been divided among family members through the years.

Floyd had leased thirty-five acres to the investors who built the Ivanhoe apartments, leaving only ten acres for the family home, barn and dairy. In 1980, Floyd sold the remaining acres of the forty-six-acre farm that he had inherited from his father, John Johnston. He received $25,000 per acre for the land. Captain Johnston had paid only $24 for the original 323-acre tract. That same property would have sold for a few million dollars in 1980. The remaining Holsteins and equipment were sold at auction.

Johnston's Dairy left Kuehn's Dairy, known for its milk, eggs and homemade ice cream, as the only remaining dairy farm in Monroeville—and it survived until 1995. Both the Johnston and Kuehn farm properties are now occupied by nursing homes.

The Monroe in Monroeville

Joel Monroe might be surprised to learn of the impact that he had on the community in which he spent most of his adult years.

Monroe, a Virginia farmer, is said to be a distant relative of President James Monroe. Born in 1793, he married Margaret Bing of Lawrence County, Pennsylvania, on May 11, 1815, before moving to Plum Township. He continued his farming life, purchasing 122 acres and 63 perches, which were fractions of an acre, from James Tusk in 1829. Tusk bought the farm in 1792 from the original owners, John and Sarah McKee, whose deed dated from 1788. The property extended from Cross Roads Presbyterian Church, now known as the Old Stone Church, to the present municipal building on Monroeville Boulevard and northward to what is now the Garden City plan.

Joel and Margaret had nine children, not an uncommon number for farming families of the time. After all, the more children a family had, the more hands there were to help with the chores. They lived in a sturdy house constructed of hand-hewn logs.

A hamlet took form along the Northern Turnpike, the toll road between Philadelphia and Pittsburgh. The little village stretched from near the Rising Sun Inn, the stagecoach stop along the road, to the Johnston farm. The pike passed through Monroe's property near the intersection of the present-day Northern Pike and the William Penn Highway business corridor.

Monroe started selling off small lots along the Northern Turnpike to encourage development in the heart of the emerging community. By the time Patton Township was established in 1849, the small hamlet was capable of supporting a post office of its own.

After a petition by Monroe and his neighbors was granted on January 23, 1851, he was appointed as the first postmaster. At the time, the postal service custom was to select a name with local meaning for the post office. Monroe was the hamlet's first squire and owner of its first general store. Stagecoach drivers had nicknamed the hamlet "Monroeville"—so that was the name selected.

The post office was located in his home, near the tollgate of the Northern Turnpike, a convenient location for the stagecoaches that passed through

From Frontier to Boomtown

Joel Monroe was the first postmaster of the tiny hamlet. *Courtesy Monroeville Historical Society.*

to deliver and pick up mail as they changed horses. A small building off to one side that once served as the washhouse became the post office for Monroeville, Pennsylvania, during Monroe's time as postmaster.

His days as a postmaster were short-lived. Monroe resigned from the job in 1855. He and Margaret bought a farm in New Castle, Pennsylvania, and moved there. He sold the Patton Township farm to his daughter and son-in-law, Rebecca Monroe Duff and Henry Duff, for $1,500. Margaret Monroe was killed in a house fire in 1864, and Joel Monroe died on April 14, 1877.

After Monroe departed, the post office was moved to the home of Matthew Snodgrass, along what is now Monroeville Boulevard near Stroschein Road. Emanuel Kunkle was the next postmaster, followed by T.B. Ferguson. Eli Myers (son of Martha Miers) was appointed postmaster in 1880 and operated the post office from a store room along Northern Pike.

In those days, rural Patton Township homes received mail once per week on Saturday. Mail delivery increased to two days, Wednesday and Saturday, and then to three days when a Monday delivery was added. Daily mail

Margaret Monroe, wife of Joel Monroe. *Courtesy Monroeville Historical Society.*

delivery didn't begin until 1905 when the federal post office established Rural Free Delivery, enabling Patton residents to receive mail placed in a box at their doors. The Monroeville Post Office was consolidated in the early 1920s when post offices were located along mail train lines and rural deliveries were made by automobile.

When the first William Penn Highway was built between 1924 and 1926, parts on the northern end of the Duff farm were developed to accommodate gas stations, greenhouses, roadhouses, a hotel, diners and a real estate office. Later, when the second William Penn Highway was completed in 1942, the southern end of the farm was developed for commercial use. Annie Duff, a daughter of Rebecca and Henry, was reported to have sold some of the land along William Penn Highway in 1940 for the mere sum of one dollar per acre.

From Frontier to Boomtown

When Patton Township residents switched to a borough form of government, they needed a new name to identify the area. After much thought, the group appointed to give the borough a name decided on Monroeville, not to honor the first postmaster, but rather because many maps already identified Monroeville as a point in the borough.

The Monroe name lives on as the name of the municipality and also in the name of Monroeville Boulevard, as well Monroe Street and Monroe Drive, both located on what was once Joel Monroe's property. But the Duff name also survives as the name of the road that connects William Penn and Old William Penn highways.

The Duff farmhouse was sold in 1953 to Myles Sampson, a noted local builder who developed the renowned Garden City—an affordable, stylish suburban housing plan. Monroe's original house was razed in 1964, replaced by a Busy Beaver home improvement store. Beneath the peeling, grayish weatherboard on the exterior stood a sturdy log house with a kitchen attached to the back.

In the last days, the landmark on the once rural Monroe homestead stood abandoned, silent and dark, with its windows broken and gone and its doors ajar and warped as the lights and noise of progress danced together along the nearby highway.

School Days

Education has always been an important facet of life for residents of rural Patton Township and modern Monroeville.

The first one-room school opened in a log cabin behind Cross Roads Presbyterian Church even before the Civil War. Dr. T.C. Robinson was teacher for the first handful of eager learners.

After Patton Township School District organized in about 1850, a one-room school, located across from the church, was built in 1859. Boys carried coal from the nearby coal house to stoke the potbellied stove, and girls hauled buckets of water from surrounding homes.

Soon after, local children went to school in one of the approximately ten one-room schoolhouses scattered throughout the township. The schools were plain and basic, employing one teacher who would instruct all students in grades one through eight. Older children helped the younger ones learn.

The teacher was also custodian, charged with keeping the school clean. Because books and supplies were scarce, each child had to furnish his or her own. Though the schools lacked the technology that permeates today's

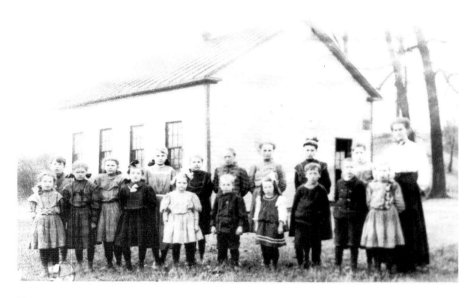

The one-room Haymaker School was located between Saunders Station and Haymaker Roads. *Courtesy Monroeville Historical Society.*

learning process, students received a good basic education adequate for their rural existence.

Haymaker School was located between Saunders Station and Haymaker Roads; Unity School at what is now the Brookside trailer court on Old William Penn Highway near Route 286; Roosevelt School on Thompson Run Road; McCann on James Street between Turtle Creek and Monroeville; and Breakneck, or McCune School, near present-day Shangri La. Mount Pleasant, McClure, Brinton and Boyd Hill were also among the other schools at which township students learned.

Another one-room school was Clugston School, located on Beatty Road near what is now Ruth Drive from 1905 to 1927. It was named for the Clugston family, which owned property in that area. The school may have been placed there because of a nearby spring—the boys were sent to haul in heavy buckets of water several times a day.

As the population grew, other schools were built. When Turtle Creek was incorporated in 1891, it assumed responsibility for the schools, even though Patton Township students still attended classes there. Because of overcrowding, a new school was built on Church Street in Turtle Creek to serve students from both municipalities. In 1917, when Turtle Creek annexed the Electric Plan of Patton Township, the borough took charge of the eight-

room school there. Later that same year, another two Patton schools were absorbed by Turtle Creek when it annexed other parts of the township.

In 1892, a two-story, four-room building was constructed in Pitcairn under the direction of the Patton Township School Board. All of the rooms were in use by the time Pitcairn became a borough two years later. With Pitcairn booming, a new six-room, red brick school was dedicated in 1896 on Sixth Street. The first seven high school students attended classes on the upper floor. They completed a two-year course of study, and the first graduation was held in 1898. The next year, an addition included four classrooms on the first floor and an auditorium on the second. The school was eventually used as an elementary building, and today serves as the Pitcairn Borough Building.

Schools continued to be built in Pitcairn, including one on Agatha Street, followed by a high school across the street. A two-year program was offered to high school students through 1923, when the first four-year class graduated. Nine classrooms and a gymnasium were added, and the building is currently used as Pitcairn Elementary School. Pitcairn Building No. 4 was constructed at the corner of Pennsylvania and School Streets, before Pitcairn annexed that part of Patton Township.

Roosevelt School, in 1907, was on Thompson Run Road. *Courtesy Monroeville Historical Society.*

Remembering Monroeville

By 1911, Patton Township began a consolidation program, creating buildings with multiple rooms to handle a growing population. Monroeville Elementary School, built on Northern Pike in 1911, was demolished in 1982. Bellwood Public School near the corner of Ohio Street and Bellwood Road was built in 1912 to handle an influx of mining families. The school eventually became a recreation center but was razed and replaced by a small park. Mellon Plan School was built in 1927, as was Jordan School on Grandview Avenue. Patton Junior High, which became Patton Elementary School, was completed in 1939.

While Patton Township elementary and junior high students were educated within the township's borders, there was no high school. Older students had to choose between Pitcairn, Westinghouse Memorial (Wilmerding) or Turtle Creek (Union) High Schools to complete their education as tuition students. The cost was paid by the Patton Township School District.

Monroeville School District and Pitcairn merged into a joint school district in July 1955, and soon the district contained ten elementary buildings, two junior highs and a senior high in the borders of Monroeville. The growth in Monroeville's population from 7,841 in 1950 to 17,156 in 1958 necessitated these newer, larger schools to accommodate the families moving to the borough.

The buildings added were Monroeville Junior High in 1955, Moss Side Elementary School in 1956, Evergreen Elementary in 1957 and Gateway Senior High and Northern Pike Elementary in 1958. The last new school, Ramsey Elementary, was built in 1970.

Over time, the public school system changed names about the same number of times as the municipality—from Patton Township School District to Monroeville School District to Monroeville Pitcairn Joint School District to Gateway Union School District to Gateway School District.

St. Bernadette and North American Martyrs Catholic Schools were established in the 1960s to serve families who wanted a religion-based education for their students through eighth grade. Our Lady of Mercy Academy opened in 1963 as a Catholic girls' high school in the University Park section of Monroeville but closed in 1979. The building is now home to Greater Works Academy, a Christian school serving students through grade twelve. Western Pennsylvania Cultural Center operates Snowdrop Elementary School, a private science academy, on Northern Pike. Sunrise School serves mentally challenged students from the East Suburbs, while Spectrum Charter School and Milestone Achievement Center of America serve autistic and learning-disabled students.

In the late 1960s, Community College of Allegheny County opened its Boyce Campus on Beatty Road. Across the street is Forbes Road Career and

From Frontier to Boomtown

Technology Center, which opened in 1959 as Forbes Trail Area Vocational School, providing vocational and technical education for students from nine participating school districts. Today, there are proprietary schools that provide a number of postsecondary education programs, and residents also can take advantage of courses offered by many area colleges and universities at locations in Monroeville.

Down on the Farm

As Pitcairn, Turtle Creek and Wilmerding flourished in the late 1890s, Patton Township remained in the dark, literally. With the industrial Westinghouse Valley just over the hill aglow in the electric age, Patton Township remained with no paved roads, no electricity, no telephones and no powered means of transportation.

Peoples Gas opened a line into Monroeville in 1908, and gas heat slowly began to replace wood and coal-burning stoves. By 1912, Bell Telephone began installing phone lines, and seven subscribers along Monroeville Road paid $1.50 per month for service.

Patton Township had a number of villages and hamlets by the early 1900s, including Adderly, Boyd Hill, Clugston, Fort Wilden, Hall, Newton Station, Patton, Saunders, Shantytown and Wesley. Bellwood Acres and Mellon Plan were the township's first housing plans.

Monroeville Road, and others that ran south, connected Patton Township with the industrial valley towns that had seceded to become boroughs in the late 1800s. There was some migration from those towns out to "the country" as the automobile made local travel easier. The state improved Northern Pike, and cars started to travel the same road used by stagecoaches a century before. In the early 1920s, Fox Plan developed along the old pike. But there was no snow removal along the country roads, unless a farmer with workhorses decided to skim off a layer of deep snow near his home.

In 1910, Patton Township had only 3,210 residents. By 1930, that number had only grown to 4,687. Of that number, 226 were African Americans, mostly employees of Westinghouse Air Brake Co. and who lived in the Boyd Hill section. The growth was enough to warrant the first fire company, which organized in 1926, but water to fight fires didn't come from a hydrant. In fact, city water didn't start to replace well water until 1949, when Patton Township established its water authority.

In a January 27, 1971 article in the *Times-Express*, Sam Jenkins, who served as a justice of the peace, burgess and state representative, said that farming,

coal mining and moonshining were the chief industries when he moved to Patton Township in 1927. And he wasn't kidding. Many of the farms had stills well into the twentieth century.

Though the mining subsided over the next decade or so, not much changed. By 1940, Patton Township had only four industries—Houston-Starr Co., a brick-building firm; McClintock-Welsh Lumber Company; Thomas Harper Coal Co.; and the Hall Station Union Railroad roundhouse and shop. Those who weren't farmers worked in restaurants, gas stations or motels along Old William Penn Highway and, later, Route 22—or traveled to jobs in the Westinghouse plants or U.S. Steel's Edgar Thomson works in Braddock.

Families shopped in Braddock, Turtle Creek, Pitcairn, Wilkinsburg and the downtown and East Liberty sections of Pittsburgh. Even if they had cars, Patton Township residents were more likely to park them and catch a ride to shopping areas on the trolleys and buses that had regular service through Pitcairn and Turtle Creek.

Joan Ridgeway Walton, who lived in Bellwood Acres, remembers that her mother would call in an order to Orr's, a grocery store in Turtle Creek. Her father, who owned a service station there, would pick up the order on his way home from work. Movie theatres in Pitcairn, Turtle Creek and East Pittsburgh drew Patton Township families. Walton traveled to Wilkinsburg for tap dancing lessons.

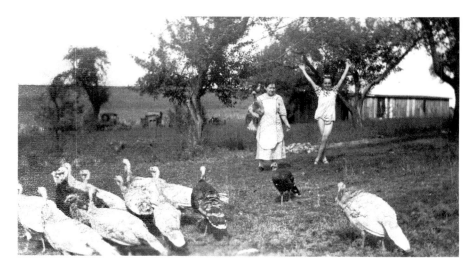

Country life brought chores but also carefree moments for Betty Miller and daughter Clara Louise on the old McGinley farm in 1936. *Courtesy Monroeville Historical Society.*

From Frontier to Boomtown

During the first half of the twentieth century, life in Patton Township was simple. Many of the houses that weren't on farms had lots big enough to accommodate large gardens and some fruit trees. Families with large yards often had chicken coops and even sold their own eggs to neighbors. Men planted gardens with beans and berries, rhubarb and radishes, lettuce and corn. Women canned the harvest, storing the sterilized Mason jars with an assortment of vegetables and fruits for safekeeping in the fruit cellar to last the winter months.

Milkmen and hucksters sold dairy products and produce to those without their own farms. Other residents bought their produce at farm stands. In 1908, the Hohmann family opened an outdoor market on James Street, selling homegrown fruits and vegetables from their farm. In later years, they built a market and a small shopping plaza on the site. Other farmers also operated produce stands along the local roads.

The rural families slowly traded in their scrub boards for wringer washers. Women did their washloads in the morning and then hung them on outdoor clotheslines to blow dry in the breeze. Because the area was safe, children were free to play games, walk to neighboring farms or through the woods, hold picnics or go sled riding. They often disappeared in the morning and didn't return until dinnertime. After commercial radio was established in the Westinghouse building in neighboring Turtle Creek, it provided a new form of entertainment for families. Still, though, many gathered around the piano and sang for fun.

Walton and her friend, Jean Winkler Colbaugh, spent much of their free time growing up in the mid-1900s caring for and riding horses. The beautiful animals provided recreation for both children and adults. Colbaugh's father had a farm with many horses and ponies. She spent time cleaning the barn and feeding and taking care of horses, but the reward was getting to go with her father to horse shows. Some were in Monroeville, but most were in Irwin and Greensburg. Her father also took the horses to area street fairs.

The Winklers had a pony track located near Bellwood School where local children, including Walton, learned to ride. Eventually, Walton's father bought a pony from a local farmer. The two girls rode their horses throughout Monroeville on the dirt country roads and in the mined area that eventually became Monroeville Mall. Walton and her father showed their horses, too, earning some two hundred ribbons with Orders Delta Queen, their Tennessee walking horse, and Royals Rosemarie, a five-gaited filly.

The Speelman family had a track used by neighbors where Hillcrest United Presbyterian Church stands today. The Solomons boarded, raised and raced horses when they lived at the old McGinley House. An oval

Even into the 1950s, horses were commonplace on Patton Township farms. *Courtesy Monroeville Historical Society.*

behind their house provided a place where children learned to ride, and Harry Solomon exercised and trained his trotters for horse races in his sulky cart. Even into the 1960s, there were community horse rallies where riders gathered to travel the township's remaining rural roads.

The day of the horses gave way to horsepower and farms to housing plans, as the automobile and highways turned rural Patton Township to suburban Monroeville.

PART III
WHISTLES, WHEELS AND WINGS

THE TRACKS OF PROGRESS

Until the mid-1800s, horses and horse-pulled wagons or buggies were the only way to get from here to there, other than walking.

In 1827, the Baltimore & Ohio was chartered as the nation's first railroad. But it wasn't until 1846, when the Pennsylvania Railroad—the "Standard Railroad of the World" and the nation's first big business—made its way to the Pittsburgh area that Patton Township would feel its impact.

The Pennsy, as it was known, had its first run from Pittsburgh to Turtle Creek on December 10, 1851. From there, eastbound passengers had to hop aboard a stagecoach to carry them to the next station, twenty-eight miles away. Nearly a year later, on November 29, 1852, service opened from Philadelphia to Pittsburgh.

The railroad intersected stagecoach routes and Indian trails, providing access to the coal fields, serving industry and bringing people to look for work and a place to live. Much of the expansion into western Pennsylvania and eventually to the West can be linked to the railroad, especially the mainline of the Pennsylvania Railroad and its many branches.

Where towns existed, they grew further, including the villages in the southern end of Patton Township. When the Twenty-eighth Steel Yards in Pittsburgh could no longer carry the growing load, Robert Pitcairn, superintendent of the Pennsylvania Division of the Pennsylvania Railroad, saw potential in the area near Wall Station. At Pitcairn's urging, the Pennsylvania Railroad constructed new classification and receiving yards there in 1892 on 250 acres of farmland that led to rapid development of the town that now bears his name. Eventually, the Pitcairn Yards had two round houses, two gravity humps and thirty-five lines.

Remembering Monroeville

When inventor-industrialist George Westinghouse brought his factories to the Turtle Creek Valley, he strategically placed them along the Pennsy's lines, which connected his businesses from Trafford to Pittsburgh. Trains from the branch lines that served the Murrysville gas fields, Export mines and dairy farms of Penn Township all came through Trafford, just to the east of Patton Township. The Turtle Creek branch of the Pennsylvania Railroad ran along the parts of the township that border Westmoreland County, providing transportation for residents employed at the Westinghouse plants or the Edgar Thomson steelworks in nearby Braddock. Patton Township had a station on the branch line at Saunders Station Road.

The Edgar Thomson Works began operations in 1875, using the Bessemer process for the mass production of steel. However, Andrew Carnegie, who owned the mill, did not buy into the Pennsy's monopoly for industrial transportation. He formed his own railroad to connect to the iron ore and coal docks at Conneaut on Lake Erie with his Mon Valley steelworks.

Several smaller companies had constructed sections of a route that by 1892 had extended north to reach the port of Conneaut, Ohio. The extensions carried their own corporate names and survived a series of reorganizations to become the Pittsburgh, Shenango & Lake Erie. The rail line had been completed as far as Butler, still forty miles distant from Carnegie's Mon Valley works.

In April 1896, an agreement between PS&LE, Union Railroad Company and Carnegie Steel Company called for construction of a north–south line from Butler to East Pittsburgh that was put into service on October 27, 1897. In 1897, PS&LE and Buffalo & Pittsburgh were consolidated into the Pittsburgh, Bessemer & Lake Erie under majority ownership of Carnegie.

Four years later, Carnegie formed the Bessemer & Lake Erie Railroad under his exclusive ownership and arranged to lease PS&LE for 999 years. This arrangement stayed in place with the formation of U. S. Steel in 1901, which bought out Carnegie's interests. In 1906, B&LE leased, and later sold, to Union Railroad the line between North Bessemer in Penn Hills and East Pittsburgh, including a portion that skirted the western border of Patton Township.

The B&LE crossed multiple stream valleys in the northern part of the town of Turtle Creek on a quite lengthy wooden trestle. On his website www.pghbridges.com (Bridges and Tunnels of Allegheny County and Pittsburgh, PA), author Bruce Cridlebaugh observes that it seems ironic that a railroad built expressly for the purpose of delivering the raw materials of the steel industry at Edgar Thomson Works would construct so many wooden structures to carry the heavy products for the steel industry. All of them

From Frontier to Boomtown

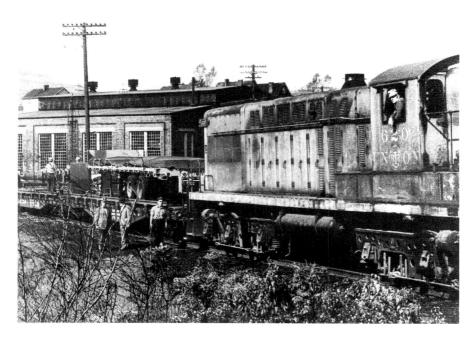

This Union Railroad train is headed for the roundhouse at Hall Station. *Courtesy Monroeville Historical Society.*

would in time be replaced or simply covered over with slag waste products from the steel mill.

The Union Railroad name truly reflects how it came to be—a union of all or parts of five railroads consolidated between the years 1906 and 1915. Union Railroad's Hall Station Shop opened in 1908 on the border of Patton and Wilkins Townships. The roundhouse and turntable built then along Thompson Run Road are still in service today.

While the major railroads were busy on the eastern, western and southern ends of Patton Township, eventually costing the township the portions that became Pitcairn, Turtle Creek and Wilmerding, there was a different kind of rail activity occurring in other parts of the township. A narrow-gauge railroad ran from a coal tipple on Old William Penn Highway to the top of the hill near Duff Road, across to Center/Stroschein Road and then through the Miracle Mile Shopping Center area, where it branched north and south. The north track dropped down along what is now old William Penn Highway in the vicinity of LaBarbe, giving the road there the name Trestle Road. The small locomotive that serviced the mine was known as a "dinky."

Removing the coal train tracks was a laborious task for these workers in 1930. *Courtesy Monroeville Historical Society.*

An engineer named John McCreary was unable to stop his dinky in 1923 because no one had sanded the tracks along the trestle bridge located a short distance from what is now Route 48. McCreary went over the trestle but lived to tell about it. When the coal was gone, the railroad was removed, though evidence of some tracks remained in the ground behind Lilac Drive when the Garden City plan opened in 1953.

By then, the Pennsylvania Railroad had begun phasing out its passenger service, and train stations in the Turtle Creek Valley towns ceased to exist.

The mighty Pennsy itself stopped on the tracks in 1968, when a merger with New York Central produced Penn Central, which in 1970 became the biggest case of bankruptcy in the nation's history until that point in time. In 1971, Amtrak took over the passenger route, though Pittsburgh and Greensburg are the closest stops remaining.

About twenty-five years after the Pennsylvania Railroad renovated its Conway Yards in Beaver County and shifted much of the traffic there, all operations at the Pitcairn rail yards ended. For the two decades after the yards closed in 1979, the droning noise of engines and their lonesome whistles, particularly in the still of the night, were few and far between.

New life came to the rail yards and the valley's tracks, however, when the Norfolk Southern Intermodal Terminal opened in 1998. Rail intermodal service is the movement of trailers or containers by rail and at least one other mode of transportation. Truck trailers, minus the driver and cab, are secured on well cars and often double stacked.

From Frontier to Boomtown

Although not located in Monroeville, the traffic from the facility right on the municipal border is apparent on Route 48 as the trucks pick up the trailers and head for either Interstate 376 (Parkway East) or the Pennsylvania Turnpike.

The First William Penn Highway

There's no question that the popularity of the automobile helped to fuel the growth of Patton Township and its transformation into Monroeville.

The William Penn Highway Association of Pennsylvania was organized on March 27, 1916, when 650 road supporters from towns along the proposed route met in an auditorium in Harrisburg. Their goal was a road paralleling the Pennsylvania Railroad that could provide an alternative route to the Lincoln Highway between Philadelphia and Pittsburgh.

With the number of automobiles increasing, the pace of road-building began picking up speed across the country. Not only was there a desire for better local roads, but the automobile also began to replace the train for longer trips.

As the number of automobiles and trucks on the nation's roads grew, the federal government began to aid the states in building highways that were necessary for long-distance travel. Although Route 30, just a few miles south of Patton Township, was the nation's first coast-to-coast highway, the Pennsylvania Department of Highways jumped onboard a plan for U.S. Route 22, designed to provide a better road that would generally follow the route of the old Northern Turnpike.

In November 1921, a federal aid program was adopted that would have a major impact on construction of key highways all over the United States. That year, a committee of local citizens from many of the towns along the proposed route, some of which had developed during the heyday of the Northern Turnpike, visited state officials in Harrisburg to encourage the commonwealth to proceed with plans to pave the old stagecoach road from Patton Township through neighboring Franklin Township (Murrysville) and on to Delmont.

As it had been since General John Forbes's troops built Forbes Road in 1758 as the westward route to Pittsburgh, Patton Township would be included along the path. Forbes Road, which became Old Frankstown Road, eventually formed the northern border when Patton separated from Plum Township.

An Indian trail through the township had formed the route of Northern Pike when it was developed as a stagecoach route. Even with improvements,

Northern Pike's hilly, narrow, winding path offered challenges for automobiles that had been designed for city driving, not to mention the fact it still served as a road for local carriage traffic. Patton Township residents who were headed for the city usually took a horse and buggy to Turtle Creek or Pitcairn and then a streetcar, a trip that consumed a whole day.

After entering Allegheny County from the east along the Northern Pike, the new William Penn Highway crossed Abers Creek and, at that point, diverged where Northern Pike began a difficult climb to follow a ridgeline. The highway took a more northern route, following older water level roads connecting creek valleys as they traversed Patton Township.

The new route incorporated a section of Lick Run Road, using the stone underpass built at the western end of the road in 1902 beneath the Bessemer & Lake Erie (now the Union) Railroad tracks and then climbing a hill out of the Thompson Run Valley, resuming the route of Northern Pike toward Pittsburgh. The new alignment bypassed a particularly hilly section of Northern Pike by following the more level creek beds. Over time, there would be two more alignments of U.S. Route 22 that paralleled the original William Penn Highway—first one to the south and then another to the north.

When the original William Penn Highway opened in 1926, it was bestowed with the description of "the best paved road in the state." The two-lane road

The Gravity Fill gas station on the first Route 22. *Courtesy Monroeville Historical Society.*

From Frontier to Boomtown

improved parts of Northern Pike and other local roads where they were used to create the new route.

City dwellers escaped by automobile to Patton Township for pleasant day trips away from the soot and stench of the mills. Shortly after the highway opened, so did Burke Glen, an amusement park built to lure the motoring public out of the city and into the fresh air and countryside of Patton Township.

The road spurred commercial development along the stretch of the highway through Patton Township. Though the township remained sparsely populated between pasturelands and woodlands, several businesses catering to travelers popped up along William Penn Highway, the first real commercial growth that the interior portion of Patton Township had ever experienced. Soon, there were gas stations, restaurants, motels and night clubs along the route.

Some of these early ventures had an element of novelty designed to convince travelers to stop. The Old Windmill Restaurant, with its arms greeting customers, was a prominent fixture along the highway. LaBarbe, an outdoor barbecue stand, was one of the first eateries when the road opened in 1926.

The Gravity Fill gas station was one of the earliest to provide fuel in Patton Township. Situated beneath the Union Railroad's siding on a nearby hill, the station's holding tanks were filled directly from railroad tank cars above, thus the name.

The Old Windmill restaurant along the first William Penn Highway. *Courtesy Monroeville Historical Society.*

Two establishments offered cabin-type lodging in the vicinity of what is now Garden City, and a bit more to the east, two speakeasies opened during Prohibition, providing a safer haven from law enforcement authorities on the isolated country road in Patton Township.

Though the highway's heyday lasted a mere two decades, the road is still a secondary corridor for commercial establishments and some residential homes. Though the Pennsylvania Department of Transportation has been working over several years to expand the one-lane sections of the original highway through rural sections of the state between Monroeville and Altoona, some of those sections that remain or are visible next to new alignments are reminiscent of the rural flavor of the first William Penn Highway.

Takeoff

It may have seemed that the development of neighboring boroughs had pretty much left Patton Township in the dust of its farms and rural roads, but the township was the perfect place for a form of transportation more modern than the train—the airplane.

When fighter pilots returned from service during World War I, they obtained surplus planes and took to the air at home. Farmers' fields became landing strips. Some actually became dedicated airstrips.

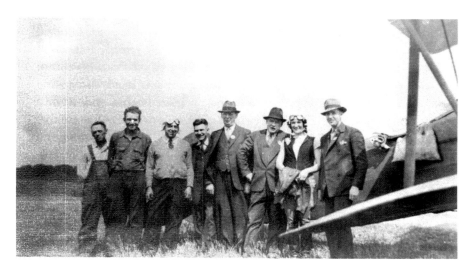

Officials gathered for the dedication of the Johnston airfield as an airmail pickup point in May 1938. *Courtesy Monroeville Historical Society.*

From Frontier to Boomtown

Three airfields developed in Patton Township, the first of which was the East Pittsburgh Landing Field, more commonly known as Johnston's airport, which opened in 1926. The George Johnston family, descendants of original homesteader William Johnston, owned and operated the airfield behind their home off Johnston Road in the Mellon Plan. In May 1938, the airfield was dedicated as an airmail drop-off and pickup point for the Wilmerding Post Office.

The airfield had an office, restaurant and public telephone to serve the pilots who came and went. Many of the young men who learned to fly there became military pilots during World War II. Not only were there planes, but an occasional blimp would also moor at the airfield before taking off for its next destination. Johnston's airport drew crowds for air shows, where barnstorming pilots would amaze spectators with their daredevil stunts.

Interestingly, in her book *Hamlet to Highways: A History of Monroeville, Pennsylvania*, the late Marilyn Chandler wrote about an interview she had done with the family of George Johnston. Evidently, Johnston was a member of the Improved Order of Red Men, the nation's oldest patriotic fraternal organization, which held meetings at the airport. The group held a politically and socially conservative philosophy.

The last plane landed there in the early 1970s. Today, it is the site of Waste Management's Monroeville landfill.

The second airstrip was officially known as Pitt-Wilkins Airport but is generally referred to as Bohinski Field. Founded by Emil Bohinski on his father's property off Tilbrook Road, it lasted only from the early 1940s until it was decommissioned about 1948 but was important in training young men to be pilots during World War II. With no restrictions, daring pilots would fly upside down and buzz homes.

Bohinski Field was the main airmail transfer point for the Pitcairn Post Office. The airport used an aerial pickup system devised by Dr. Lytle S. Adams of Irwin. When Adams realized the time lost in takeoffs and landings for airmail delivery, he invented a system to speed up the process. By suspending a mailbag between two forty-foot poles, a low-flying plane could snag it with a hanging hook. The system was used by hundreds of small-town airports and ensured a speedier delivery of airmail. Today, Bohinski Field is the site of Monroeville Community Park.

Harold W. Brown, a flight instructor at Bohinski Field who trained U.S. Army cadets, opened the third airport in Patton Township with his wife, Helen Bohinski Brown, whom he'd met at her family's airfield. Brown bought land on what was once the Beatty farm for the Wilkinsburg-Pittsburgh Air Park in 1948, the same year that Bohinski Field ceased operation. The

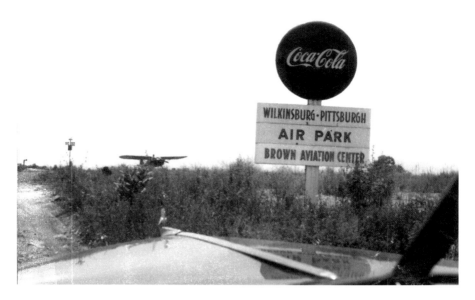

The Wilkinsburg-Pittsburgh Air Park is still in operation as Monroeville-Pittsburgh Airport. *Courtesy Monroeville Historical Society.*

airfield opened in 1950. In later years, the airport was officially known as Pittsburgh-Monroeville Airport.

The modern facility off Logans Ferry Road and adjacent to the back end of Garden City was able to handle a significant amount of light plane traffic. Pittsburgh-Monroeville Airport offered more amenities than its local predecessors, including a 2,287-foot-long runway, hangar space and fueling for local and incoming planes. By 1958, the two long hangars housed 112 aircraft.

The timing of the airport coincided with a number of major industries locating their research facilities in Monroeville. The airfield provided a convenience for business travelers who could land their private planes and catch a taxicab to the nearby corporate offices. It also became popular when skiers flew in to have fun on the ski slopes at nearby Boyce Park in the late 1960s. Flying clubs also used the airport as a meeting point.

After her husband died in 1967, Helen Brown took over operations, keeping the airfield open from 9:00 a.m. until 10:00 or 11:00 p.m., pumping gas and managing the office. Raymond Weible, who eventually helped Brown manage the facility, unofficially dubbed the facility the Harold W. Brown Memorial Field in honor of its founder.

From Frontier to Boomtown

By the end of the 1960s, Brown Aviation Field was the only privately operated field with a hard surface runway in Allegheny County. Planes came and went without incident until, in January 1970, an airplane bounced off the roof of a home in Garden City when it stalled at takeoff and skidded to a stop on Greenleaf Road.

When the airport opened, there were only three houses in the area, but when Garden City was built in the early 1950s, the neighborhood began to develop. Garden City residents, upset by the incident, appealed to Monroeville Borough Council to ban takeoffs between 11:00 p.m. and 7:00 a.m. to reduce nighttime noise from the sixty-seven-acre complex. Eventually, Brown and officials worked out a deal that prohibited joy rides and flying lessons during the restricted hours but allowed planes to take off for destinations outside the borough and permit craft to land if the flight originated outside Monroeville.

It wasn't the last air issue that Monroeville officials had to deal with. In 1974, plans were submitted for a heliport adjacent to Sheraton Inn on the Mall, in the Monroeville Mall complex, to provide shuttle service from the mall to Greater Pittsburgh Airport. After initiating the service on a bare-ground helistop next to the hotel, the venture proved only marginally successful. The company withdrew the plans it had submitted to the municipality.

However, Al Monzo, owner of the Palace Inn at the corner of Routes 22 and 48, was successful in his bid to get a heliport located adjacent to his hotel in 1988. The hotel has been razed, but a heliport could be included as the University of Pittsburgh Medical Center proceeds with plans to open a hospital there. Western Pennsylvania Hospital-Forbes Regional Campus on Haymaker Road—opened in the late 1970s as East Suburban Health Center to meet the medical needs of the growing suburbs—also has a heliport for emergency medical air transport.

Although fewer than twenty planes are housed in the hangars now, Monroeville-Pittsburgh Airport still has about two thousand takeoffs and landings a year.

The propeller noises from the flights from the heliports and the Brown Aviation Field continue to draw eyes to the sky. Those on the ground can still dream that they can fly up, up and away.

A Highway and Byway

America's love affair with the automobile only grew in time and, less than two decades after the state built William Penn Highway, officials

decided that a better, more modern roadway was needed to handle the increased traffic.

Built as a three-lane highway, the new U.S. Route 22 contributed to the explosion of suburban growth that turned rural Patton Township into modern, metropolitan Monroeville. Improved construction machinery enabled engineers to design, and workers to create, straighter, wider roads utilizing cuts and fills.

Actually, the designers of Route 22 running through Patton Township were able to capitalize on some work done by R.H. Cunningham & Sons, a general contractor from Penn Avenue in Turtle Creek that was involved in mining operations in the vicinity of the present-day Miracle Mile Shopping Center. In connection with the strip mining operations on the Daniel McMaster farm, Cunningham wrote to the township commissioners in 1923 to ask permission to change the grade of the road leading from Northern Pike to Stewart Station near the residence of Watson McMaster to the residence of Daniel McMaster.

Cunningham told the commissioners that by changing the grade of the road the company could eliminate a very steep grade and make travel over it much easier, enabling better travel and allowing for transportation of larger loads with less effort.

Mining operations also filled in around the trestles that crossed many gullies along what would become the footprint of the highway, creating a flat area for a few miles in the vicinity of the hamlet of Monroeville.

Construction of stronger, higher bridges enabled the new roadways, including the new William Penn Highway, to leap deep valleys. Plans called for a 1,127-foot-long bridge to be built over the Thompson Run Valley in the vicinity of Hall Station to cross the stream and road below. Though the highway opened in 1942, completion of the bridge was delayed because the steel for the trusses was needed for military uses during World War II.

When the war was over, though, the state completed the steel spandrel-braced deck arch that looms 349 feet above Thompson Run Road and about 300 feet over the Union Railroad tracks at the border of Patton and Wilkins Townships.

The new highway took traffic away from the established businesses along the first Route 22 and destroyed the essence of Burke Glen Amusement Park by taking a wider swatch of property to improve the highway. The realignment also cut off a section of Old William Penn Highway and blocked off McGregor Road, which had connected the highway with Northern Pike near Center Road. An old stone bridge on McGregor, which has conflicting dates of construction ranging from the 1860s to 1900, became unnecessary

From Frontier to Boomtown

when the new highway was built. Monroeville Historical Society had a hand in saving the historic bridge in the 1970s, and it is now a Pittsburgh History and Landmarks Foundation historic landmark.

The new and improved William Penn Highway assumed the U.S. Route 22 (William Penn Highway) name, removing the designation from the original highway, which became known as Old William Penn Highway or, colloquially, as Old 22.

As with the original William Penn Highway, a number of establishments appeared to service travelers. Tucker's Diner, Tucker's Hotel and Art's Gas Station stood alone in 1946 where the Duff Farm once had fields. By 1948, Beatty's Restaurant and Gulf station, offering twenty-four-hour service, had joined them at the corner of William Penn Highway and Center/Stroschein Road. Cole's Cottage Restaurant opened on the other corner.

Local farmers took advantage of the traffic and city-dwelling customers traveling Route 22 to sell their produce, such as at Miller's Roadside Stand. Catty-corner from Beatty's was Salamon Brothers, which sold groceries, meats and vegetables and had the distinction of being Patton Township's first supermarket. A frozen custard stand and a farmer's auction barn also fed off the highway.

In 1946, the Pittsburgh Outdoor Theater was built on land previously stripped for coal, another attraction for the auto-obsessed public. Admission

Salamon Bros. served customers through the 1940s and 1950s. *Courtesy Monroeville Historical Society.*

to the new drive-in was sixty-five cents for adults, forty-nine for high school students and twenty-five for elementary students. Two years later, the San Juan Motel became one of the area's first motor hotels. The motel had a popular bar at which the house organist provided nightly entertainment.

Remarkably, though, Patton Township stayed the course of its rural roots. Along Route 22, 83 percent of the land still remained as forests and farmland in 1950. That was soon to change. A commercial core was already developing along Route 22—and soon a Thorofare supermarket, Franklin Realty, Community Hardware and Penn-Super Pharmacy joined the expanding business base.

However, there is no argument that the highway, and indeed Monroeville itself, took off after two Ohio-based developers constructed Miracle Mile Shopping Center, which opened in 1954 as the largest such facility between New York and Chicago. Traffic congestion grew, and Route 22 was widened to four lanes during a highway expansion in 1957 to accommodate two lanes in each direction, plus a turning lane through the commercial corridor. A few years later, Kaufmann's Department Store, a longtime fixture in downtown Pittsburgh, and its famous Tic Toc Shop restaurant, chose a parcel beside Miracle Mile Shopping Center—the site of the Pittsburgh Outdoor Theater Drive-In—as its first suburban location in a custom-built, three-level building. When it opened in 1961, Kaufmann's had the distinction of being the largest suburban department store in the tri-state area.

A three-hundred-booth farmer's market opened along Route 22 in 1956. A few years later, the building became a Gee Willikers, a sort of hardware/garden variety store, and then was home to Cochran Pontiac and McKean Cadillac. Restaurants opened to feed the hungry—Eat'n Park, Continental Pancake Kitchen, Johnny Garneau's Original Smorgasbord, Holiday House and King's Chinese-American Restaurant. Motels opened to lodge those passing through—King's, Luzader's 22, Red Coach Inn, Turnway Inn, Phoenix, Terrace, Toll Gate, Tour-tel and Town and Country.

Only a few of the restaurants and motels from the 1950s survive today—Penn-Monroe Lounge, Esta Esta Italian restaurant and the East Exit Motel.

The commercial explosion that followed was joined by a similar growth in residential development. Monroeville became a bedroom community yet employed thousands from the surrounding communities, as well as from within its borders. Most of those who worked in the factories of the Turtle Creek Valley now had cars, and many moved to the more modern housing in Monroeville. With cars and a reliable bus system, people employed downtown chose to escape to housing in the suburbs. Once a number of

From Frontier to Boomtown

Kaufmann's Department Store opened in Monroeville in 1961. *Courtesy Monroeville Historical Society.*

industrial research facilities established themselves in Monroeville, their employees bought homes close to work.

Route 22 would see one more alignment with the completion of the Parkway East in 1962. William Penn Highway was redesignated as U.S. Business Route 22, becoming a well-traveled byway and Monroeville's commercial corridor rather than the quickest route to and from Pittsburgh.

Hub of the Suburbs

By the 1950s, the nation's wheels rolled. Soldiers who served in World War II came home, married and started their families, leaving behind the cities where they grew up in favor of new homes and a better life for their families where the grass was greener. People traveled for business and pleasure along the nation's highways.

If one were to view Monroeville as the hub of a wheel, then its highways are surely the spokes. One of the first of the present-day spokes where the

Pennsylvania Turnpike, Business Route 22 and the Parkway East come together is state Route 48.

The twenty-one-mile road provides a vital link between U.S. Routes 22 and 30. Originally, Route 48 ended at Route 30. But in 1931, Mosside Boulevard opened, providing a connection between the Turtle Creek Valley and the original William Penn Highway in Monroeville. It wasn't until the 1940s, though, that Mosside Boulevard became an extension of Route 48.

Later, Route 48 was shortened to end at the connection with the parkway; then, in 1998, it lost another fifty yards so that it ended at the junction of Business Route 22. But that didn't matter. As a collateral artery of Route 22, Route 48 has substantial commercial development of its own.

By the time Route 48 came to Monroeville, plans were already underway in the state capital for "America's First Superhighway"—the Pennsylvania Turnpike. Highways had been built with flat curves to discourage speeding, but the idea of the Turnpike was to allow traffic to move at high speeds and with no stops, except at interchanges. To meet the challenge, engineers had to design the turnpike with easy grades to enable vehicles to use it year-round and long, sweeping curves that could handle high speeds and provide safe stopping distances.

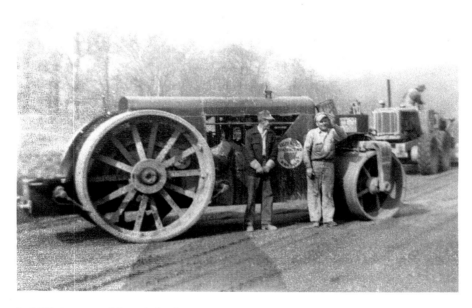

In 1951, heavy machinery helped construct the Pennsylvania Turnpike extension. *Courtesy Monroeville Historical Society.*

From Frontier to Boomtown

Work began in 1939 on 160 miles of the four-lane, all-concrete highway from near Harrisburg to Irwin, which would enable traffic to take Route 30 into Pittsburgh. Prior to the turnpike opening, travel time between Harrisburg and Pittsburgh was about five-and-a-half hours using the two-lane Lincoln or William Penn Highways. Not only was the toll road a faster, easier ride, it was also about five miles shorter than Route 30 and eighteen miles less than Route 22.

With tire and gas rationing during World War II, travel dropped on the road. But as soon as the war ended, normal traffic levels returned, and plans proceeded to expand the highway in western Pennsylvania from Irwin to the Ohio line. One of the proposed interchanges was located in Patton Township at Route 22.

Evidently, at the time the project was started, neither Patton Township nor its nearest hamlet, Monroeville, rated much attention. A newspaper clipping from the time mentioned how the turnpike would come through Pleasant Valley, cross Turtle Creek at the Allegheny-Westmoreland county line southwest of Murrysville, pass near Unity and then cross the Allegheny River at Oakmont. No mention was made of what would become the most recognizable name of all in another decade. The extension from Irwin to Monroeville opened on August 7, 1951, five months before the state dedicated the remainder of the turnpike to Ohio.

Even before the turnpike took shape, local citizens and officials had discussed improving travel within metropolitan Pittsburgh. By the late 1940s, officials knew that the time had come to provide a highway to ease traffic between Pittsburgh, the East End and Monongahela Valley mill towns.

The Penn-Lincoln Parkway had its roots in 1921, when the Citizens Committee on City Plan of Pittsburgh proposed upgrading Second Avenue into a four- and six-lane boulevard that extended through Nine Mile Run to Swissvale. The name was derived because the highway would provide a faster, more convenient route for the William Penn Highway (Route 22) through the growing suburbs on the city border and the Lincoln Highway (Route 30), until it branched off east in Wilkinsburg.

Three years later, the Boulevard of the Allies Extension Association was organized by East End residents to promote extending the boulevard through Squirrel Hill, Swissvale, Rankin and Braddock to East McKeesport, which would connect it with Route 30, the Lincoln Highway. City and county engineers began collaborating, but it was the Penn-Lincoln Highway Association, formed in 1934, that pushed for highway improvement.

The next year, Allegheny County Planning Commission proposed a highway with an alignment very similar to today's Parkway East. A caravan

The Pennsylvania Turnpike's Monroeville tollbooths circa 1955. *Courtesy Monroeville Historical Society.*

of government officials and the Penn-Lincoln Highway Association drove from Churchill in the east, just a few miles from the Patton Township border, to Campbells Run Road in the west suburbs on April 9, 1937. The drive enabled them to experience firsthand the urban landscape's frustrating traffic signals, stop signs and congestion. At a dinner that evening, they agreed to adopt Penn-Lincoln Highway as a state project.

The United States Bureau of Public Roads approved the expressway plan on September 16, 1938, but it was not until 1941 that the federal Public Roads Administration agreed to match state funds and prepare for construction of the new highway. When World War II ended in 1945, the Penn-Lincoln Parkway was ready to begin. Bulldozing began from Greensburg Pike in Churchill to Ardmore Boulevard in Wilkinsburg, starting a transportation revolution in Pittsburgh and the East Suburbs. The $31 million Penn-Lincoln Parkway project also cost the lives of six workers, three during the construction of the Squirrel Hill Tunnel. The first section of the parkway opened on June 5, 1953, and additional sections connecting parts of downtown were completed over the next few years. Though the highway

From Frontier to Boomtown

ended in Churchill, it connected with William Penn Highway, carrying eastbound traffic through Monroeville.

With the almost-concurrent opening of Miracle Mile Shopping Center and the Pennsylvania Turnpike interchange just about five miles away, the Business Route 22 retail corridor through Monroeville began developing.

The final spoke in making Monroeville the hub of the East Suburbs occurred when work began on the last link of the Penn-Lincoln Parkway from Churchill to the turnpike interchange in 1961. At that point, commercial and residential development in Monroeville and growing congestion on William Penn Highway justified the construction of a bypass. Built after the interstate highway legislation was enacted, the last section had a wide median and six lanes, compared to the earlier parkway construction with only two lanes, a shortsighted design that has caused bottlenecks at the Squirrel Hill Tunnel for decades.

The $11 million section from Churchill to Monroeville, with exits at Business Route 22 and Penn Hills, opened on October 27, 1962. While motorists hailed the alternative to busy Route 22 through Monroeville, some merchants were not as excited, dubbing the day "Black Saturday."

In an October 27, 1962 article in the *Pittsburgh Post Gazette*, one gas station owner reported a drop in sales from $420 to $150, and because his lease expired on October 31, he quit the business. Other service station owners averaged drops in business between 35 and 60 percent. John Bellissimo, a partner in the Penn-Monroe Lounge, estimated a loss of $200 a week from transient and tourist trade. But Louis "Gene" Giovannitti, who owned the Penn-Super Pharmacy on Route 22, believed that less traffic on the highway actually helped his business.

So, in the course of only four decades, Monroeville's highways had progressed from Northern Pike, the narrow, winding former stagecoach route, to the two-lane Old William Penn Highway to the four-lane William Penn Highway to the six-lane Interstate 376, better known as the Parkway East.

From dirt roads to superhighways—some things never change. In a bit of irony, today's motorists heading east along Business Route 22 or the Parkway East still face one of the aggravations encountered by stagecoach drivers on Northern Pike two hundred years ago—the blazing morning sun in their eyes.

PART IV
AN INDUSTRIAL EVOLUTION

Train Town

Colonel Anaes McKay, a military man, staked out a three-hundred-acre plantation prior to 1769 at the southeast end of what would become Plum Township.

His tract included the camp of American Indians who were defeated by Colonel Henry Bouquet's army at the Battle of Bushy Run. When Bouquet's troops reached the abandoned Indian camp along Turtle Creek, the conditions were so disgustingly filthy that they identified the site as Dirty Camp and the smaller tributary that ran through it as Dirty Camp Run.

Before McKay completed his plans, he died of exposure while crossing the mountains heading toward Philadelphia during the Revolutionary War in 1777. His daughter inherited the land, which she sold to George McDowell for £66, or about $300 then. After a few other owners, John McGinnis purchased the land in 1835.

A second three-hundred-acre tract west of the Dirty Camp land was conveyed by the commonwealth in 1789 to William Pelton and Samuel Jones. Passing through several owners, it was purchased by Michael Wall in 1820. The McGinnis and Wall tracts would form the basis of what would become present-day Pitcairn.

McGinnis laid out a plan of seven lots where Tilbrook Road crossed the Great State Road, the present-day Route 130, which ran through the Turtle Creek and Monongahela Valleys to Fort Pitt. The lots that McGinnis offered in 1841 sold quickly, and soon there were three well-built log houses and a blacksmith shop in a hamlet that became known as McGinnisville.

Just a decade later, a new form of transportation would transform the Turtle Creek Valley, including the southern end of Patton Township. The Pennsylvania Railroad laid tracks through the valley and started regular

service from Philadelphia to Pittsburgh, including stops at Wall Station, built on Michael Wall's tract.

Pittsburgh's industries grew through the 1870s. By 1880, the railroad needed more space for its terminal yards and shops. Robert Pitcairn, superintendent of the Pennsylvania Division of the Pennsylvania Railroad, saw potential in the farmland near Wall Station. Through Pitcairn's efforts, Pennsylvania Railroad completed construction on the classification and receiving yards in 1892. The complex, on 250 prime acres of farmland that stretched from present-day Wilmerding to Trafford, had extensive layouts for making up trains, a transfer, engine house, car repair shops and eastbound and westbound humps for coupling the cars.

News of the facility and the need for workers spread through the western and central counties of Pennsylvania and as far away as Europe. Families flocked to the area, and McGinnisville became a boomtown. Wall Improvement Co. and Iron City Land Co. laid out plans of lots to accommodate the influx of new residents, but the supply of homes could not keep pace with the demand. Many homeowners took in boarders until they were able to secure houses for their families.

At mealtimes, Cotter House on Center Avenue at Second Street filled with boarders. To be sure of getting a meal, workers had to purchase meal

The Pitcairn Railyards brought droves of workers to the area. *Courtesy Monroeville Historical Society.*

From Frontier to Boomtown

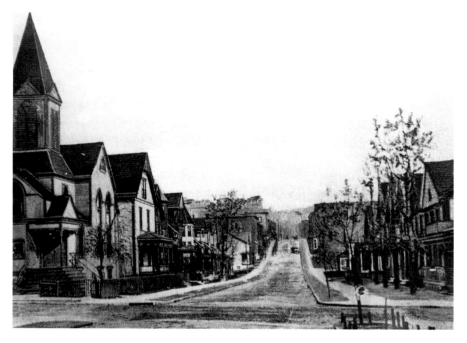

Third Street in Pitcairn grew with the railroads. *Courtesy Lillian DeDomenic, Gateway Associated Photographers.*

tickets in advance, usually on payday. In 1890, the 500 block of Third Street was the main street, with a bakery, post office, drugstore and grocery.

Businesses began to locate on lower Brinton Avenue and the east end of Broadway Boulevard (Great State Road). Liggett's and Tilbrook Brothers, both general stores, were joined by Flack's Grocery, Salyards Hardware, Laughlin's Planing Mill and Maddox Hall, a community center at which lodges met, churches held services and social gatherings took place. The stores kept popping up—Boardman's Shoe Store, Frank's Pharmacy and McIndoe's Paint Store. Hoehl's Hall at the corner of Wall Avenue became the village social center.

As the town grew, it became known as Walurba, which literally meant a suburb of Wall. Yet it was still within Patton Township and under the jurisdiction of the township supervisors. By 1893, residents dissatisfied with Patton Township officials' lack of response regarding their need for schools, building laws and improvements were practically unanimous in their support for laying the plans for a new borough government. They also wanted a name that didn't label the community as a suburb of Wall. That fall, a petition to incorporate as a borough was circulated, and on June 9, 1894, a charter was

granted to establish Pitcairn Borough, taking a chunk of Patton Township in the process.

Just four years later, residents petitioned Pitcairn Borough Council to explore the possibility of bringing electricity to the town via streetlights in front of their homes. The town fathers decided that the main street should also be lit. By then, Turtle Creek and Wilmerding had electricity, thanks to their Westinghouse facilities, but they were not interested in extending the lines to Pitcairn. The borough floated a $20,000 bond issue and erected its own electric light plant and distribution system.

For six decades, the rail yards hummed with activity and became one of the most prominent and largest classification yards on the Pennsylvania Railroad system. At its peak, the Pitcairn Yards provided jobs for about seven thousand people from throughout the Turtle Creek Valley. But in the mid-1950s, Pennsylvania Railroad renovated its Conway Yards in Beaver County and shifted much of the traffic there. And Pennsylvania Railroad itself ceased to exist after merging in 1968 with New York Central Railroad, forming the Penn Central, which filed for bankruptcy two years later.

By 1979, the Pitcairn rail yards sat silent—until 1998. That's when the Norfolk Southern Intermodal Terminal (which handles double-stacked train shipping connections) opened, bringing the sounds of the railroad to the valley once again.

You Can Be Sure, if It's Westinghouse

When the Civil War broke out, Pittsburgh, the "Iron City," was called upon to make the heavy cannons needed for the war effort. Before they were sent south, the cannons had to be tested. On the banks of Turtle Creek, a short distance east of the present-day Mosside Bridge, the weapons were loaded and fired into the hillside by expert artillerymen. The practice continued all during the war, leaving deep caverns in the bank. It was said that the best and coldest water in the area flowed from a spring in the cannonball cave. The location was known nationally as "the Proving Grounds."

Within the next quarter century, the Turtle Creek Valley would become a different kind of proving grounds—a place where inventions that would revolutionize American life were not only conceived but manufactured. It all started when George Westinghouse purchased five hundred acres in the Turtle Creek Valley for his manufacturing facilities.

Wilmerding, which had been nothing but a train station on a farm, boomed as a company town. Turtle Creek, though, already had a long history in the valley.

From Frontier to Boomtown

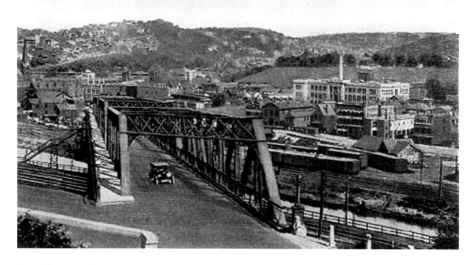

An old postcard view across the bridge leading into Turtle Creek along the Lincoln Highway.

The village in the area generally known as Turtle Creek straddled the southwest border of Patton Township and southeast end of Wilkins Township, with Thompson Run serving as the dividing line. The town got its start when Martha Miers opened her Wayside Inn in the late 1700s.

Henry Chalfant purchased the inn in 1817 and operated it until 1847. During those years, Chalfant established the area's first post office, ran a general store and offered a place for the neighbors of the surrounding area to gather for dancing. At that time, the village was known as Chalfantsburg.

In 1850, a plank road was completed between Pittsburgh and Turtle Creek, and the village became a resort to which city dwellers could easily travel by horse and buggy. Sunday was a favorite day for city folks to drive out to the "fields." As the road's popularity grew, Allen Brown, a wealthy gentleman who kept a hotel in Pittsburgh, saw a business opportunity. He built a large, fine brick hotel where the plank road met Greensburg Pike. Brown's Exchange, as it was called, cost $20,000 to construct and featured a bowling alley and other amusements. Many Pittsburghers became summer boarders, fishing in the creek, hunting in the nearby woods and attending parties at the country escape.

The first train to Turtle Creek came from Pittsburgh along the Pennsylvania Railroad tracks on December 10, 1851, and regular passenger service began the next day. By the time trains caught on, the plank road had begun to wear out. With the train serving as a better form of transportation, stockholders

refused to maintain the plank road, and soon it was in worse condition that the country dirt roads in the area.

The popularity of Brown's hotel faded quickly, and it became home to the first school for deaf-mutes in the state, later known as Western Pennsylvania School for the Deaf after it moved to Edgewood. The town's original United Presbyterian Church building was used as an academy in the early 1850s, producing many prominent citizens. In that same decade, Turtle Creek boasted one of the finest military bands in the state, the Turtle Creek Guards.

In contrast, Wilmerding was only a flag stop station on the Osborne farm along the northern side of the Pennsylvania Railroad tracks before George Westinghouse came to the valley. At the suggestion of Robert Pitcairn, then superintendent of the railroad's Pittsburgh Division, the station was called Wilmerding, for Joanna Wilmerding Negley, wife of William B. Negley, one of the farm's former owners.

As Pitcairn boomed after Pennsylvania Railroad built its rail yards there, so did Wilmerding when Westinghouse decided to purchase five hundred acres and move his Westinghouse Air Brake Company from Allegheny City to the Turtle Creek Valley. The company manufactured air compression train brakes, one of Westinghouse's many inventions. John Miller, an agent and valley native who was active in developing Wilmerding, is credited for influencing Westinghouse to make the move.

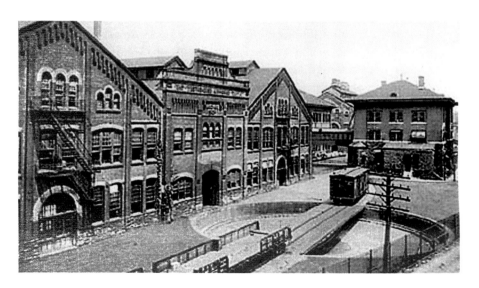

An old postcard view of the machine shop at Westinghouse Air Brake Co. in Wilmerding.

From Frontier to Boomtown

Westinghouse broke ground for the air brake works in early 1889, and by March that year, the East Pittsburgh Improvement Co. adopted and recorded its first plan for what would become the village of Wilmerding. Work started in preparation for the homes needed to house the plant's workers, including projects to grade and pave streets, lay sewer lines and construct sidewalks. Some lots were developed on the Patton Township side of Turtle Creek to accommodate the influx of workers. A segregated section of closely set bungalows was built in an area of Patton Township known as Boyd Hill to house the plant's African American workers. Mellon Plan in Patton also developed as a result of the plant.

In December 1889, the village of Wilmerding petitioned to organize as a borough from the area known as the Osborne Farm in North Versailles Township and a tract in Patton Township purchased from Thomas McMasters. By the end of 1890, the town had a population of one thousand people, and the new Westinghouse Air Brake works was operational.

Two years after Wilmerding became a borough, the village of Turtle Creek followed suit and petitioned to separate from Patton and Wilkins Townships. The request to incorporate as Turtle Creek Borough was granted in 1892.

George Westinghouse also had plans to move his Westinghouse Electric Corporation, which manufactured and promoted the use of alternating

Boyd Hill was built in Patton Township for the African American laborers at Westinghouse Air Brake Co. *Courtesy Monroeville Historical Society.*

current electrical equipment, from Pittsburgh to a new plant on his remaining property just west of the Wilmerding facility. The greatest social event of 1894 took place on September 12, when Westinghouse held a reception at the new Westinghouse Electric Corporation machine shop. More than 6,500 honored guests came to the valley, including officers and delegates of the Twenty-eighth National Encampment of the Grand Army of the Republic and a special train of dignitaries.

By 1895, his plant occupied a 250-acre site that spanned East Pittsburgh and Turtle Creek Boroughs. Over the years, the East Pittsburgh division, as it was known, became one of the company's largest operations, and many of the buildings were designed by Westinghouse himself. The local plant, which spawned residential growth in Turtle Creek and surrounding areas, housed the large rotating apparatus, switchgear and power circuit break divisions. Water wheels made at the plant harnessed the power of Niagara Falls for the New York State Power Authority, and motors made there powered the irrigation pumps at Grand Coulee Dam.

In a tiny makeshift shack atop one of the plant's eight-story buildings in Turtle Creek, Frank Conrad, an assistant chief engineer with the company, made history. The Westinghouse K Building rooftop was the site of the first commercial radio broadcast when newly licensed **KDKA** aired the Harding-Cox presidential election results on November 2, 1920.

Westinghouse had such an impact on Turtle Creek that its council once considered whether to rename the borough Electric City. Locals even referred to the Turtle Creek Valley as the Westinghouse Valley before the East Pittsburgh plant closed in 1988 and Westinghouse Air Brake stopped production at the Wilmerding facility in 1989. Keystone Commons, an industrial park, has taken over the Westinghouse Electric site, and Wabtec operates out of the old WABCO facility.

Time brought Westinghouse to Monroeville, too—but only for awhile.

Research Capital of the Nation, Gateway to the World

Monroeville's transportation system attracted more than shoppers and homeowners. As the Pennsylvania Turnpike project neared completion, the proximity to Pittsburgh and the modern highway system, combined with large areas of open space, attracted another much desired element—industry.

These were not factories and warehouses. Unlike the blue-collar jobs at the Westinghouse plants in Turtle Creek, East Pittsburgh and Wilmerding

From Frontier to Boomtown

or the railroad jobs in Pitcairn, Monroeville drew the white-collar industry workers—engineers, chemists, researchers, physicists and mathematicians.

Monroeville Council, seeing an opportunity to help expand the area, even zoned areas specifically for new research centers. Facilities built between 1956 and 1971 were designed to be integrated into neighborhoods so employees could walk to work. There was a bigger integration beyond the companies—the recruitment of talented scientists, engineers and mathematicians from around the world.

United States Steel was first to recognize the potential of Monroeville. In the 1950s, the steel industry around Pittsburgh was thriving. The company, headquartered in Pittsburgh, prided itself on being a leader in both process and product technology. In the post–World War II years, the company put money into research and into developing new products and needed a place to house that end of the company. Monroeville fit the bill.

The company purchased 142 acres for its Fundamental and Applied Research Laboratories, consolidating existing research facilities in Kearny, New Jersey, and the Oakland section of Pittsburgh. In 1953, the corporation broke ground for an administration building that officially opened in 1956. Over time, the research center grew to an eight-building complex on 210 acres, housing a staff of 1,200 on a campus-like setting.

Among the products developed there were steel "lumber," a two-piece steel beverage can and tougher steel for line pipes to carry products like oil long distances. One addition to the complex was the chemicals and plastics research building completed in 1962.

In 1967, the company purchased additional land, but the need for the room to expand ceased when the country's steel industry declined. Some parcels were sold for commercial and residential development.

U.S. Steel Research and Technology, a much downscaled version of the original research center, moved to the Waterfront in Munhall in 2006. The main complex is now being renovated as Tech One, a technology park.

Koppers came next in August 1961, developing a 176-acre tract in the University Park section of Monroeville as its central product development and testing facility. Some 350 people were employed at the chemical company. The building was the largest of seven facilities owned by Koppers. The center, noted as one of the best-equipped facilities in the country, provided research support in architectural and construction materials; plastic, chemical coatings and engineered products; environmental systems; and engineering and construction.

According to "The Technical Information Facility of Koppers' Research Center" by Eugene Meckly of Koppers, which appeared in the *Journal*

U.S. Steel brought its research lab to Monroeville in 1956. *Courtesy Monroeville Historical Society.*

of Chemical Information and Modeling in May 1968, management had very carefully chosen a site that was centrally located in respects to the homes of the research department employees and then had architects design a center to fit the terrain.

In 1988, Koppers Co. agreed to sell its environmental resources subsidiary in its first divestiture after being acquired by Beazer P.L.C. of Britain for $1.8 billion that June. Koppers sold Keystone Environmental Resources Inc., its Monroeville business, to the Pittsburgh-based Chester Engineers Inc. on the condition that Chester guaranteed all 250 nonunion workers either jobs or salaries for one year.

In 1989, PPG, headquartered in Pittsburgh, bought Koppers' Monroeville facility that is now home to its Chemicals Technical Center to consolidate its local technical units. Researchers at the Monroeville facility work to improve the efficiency of PPG's chlor-alkali production, contact lenses, amorphous silicas and fine chemicals.

Pittsburgh Corning Research and Engineering Center, just over the line in Plum Borough, was considered part of the migration of corporate research centers to the area when it opened in 1962. Pittsburgh Corning, a subsidiary

From Frontier to Boomtown

Pittsburgh Corning was counted as one of Monroeville's research facilities. *Courtesy Monroeville Historical Society.*

of PPG, conducted research in the exploration and development of new uses of glass and other materials to control heat, light and sound.

Bituminous Coal Research National Laboratory, an industry-supported coal research center affiliated with the National Coal Association, opened in 1962. At its inception, the center employed fifty researchers to work on new ideas and products, as well as conduct basic research from concept to product development, for new and improved coal applications and coal gasification.

The company merged with the University of Pittsburgh in 1963 and expanded into other energy-related topics like acid rain, air and water pollution. RJ LeeGroup, a technical and analytical consulting service, now occupies the building on Hochberg Road.

Chemical Service Engineers became part of the formula with yet another research facility.

Westinghouse Electric Corp. already operated a research and development center located in nearby Churchill Borough when the company opened its nuclear center on the old McGinley farm in Monroeville. The 197-acre tract was located on a steep bluff overlooking the Pennsylvania Turnpike. Construction began on July 31, 1969, and the finished building was dedicated on June 5, 1971.

Remembering Monroeville

Although Westinghouse was responsible for the first commercial radio broadcast, it was the tiny WPSL-AM, owned by Monroeville Broadcasting Co. that aired the dedication ceremonies when a sudden summer storm interrupted the outdoor program, so those not attending could hear the event.

Westinghouse brought another two thousand employees to Monroeville. The Nuclear Center had one of the first systems to convert "heat-of-light" into a heat-energy system, using air cooling equipment to maintain comfortable temperatures year-round by rejecting summer heat through cooling towers and distributing heat in winter months through outside wall heat exchangers.

A large percentage of new Monroeville residents in 1950 were research people. Of the personnel engaged in research in the Pittsburgh area, 3,750 were employed within a five-mile radius of Monroeville. By the mid-1970s, between the retail and business sectors, more than twenty thousand people worked in Monroeville.

The same Monroeville that was labeled a "straggling hamlet" in the 1800s was given the title "Research Center of the Nation" in 1974. Signs were proudly placed at the entrances to Monroeville, within view of all the motorists who passed the busy intersections.

Nothing lasts forever. The last of the original research centers, Westinghouse Electric Co., a part of the now-defunct Westinghouse Electric Corp., had its world headquarters and nuclear energy center located in Monroeville. That, too, will become history as the company headquarters completes a move to Butler County by 2010.

Beyond the corporate impact, the researchers who came to live in Monroeville forever changed the faces of the community. The best and brightest researchers from around the globe were recruited for jobs in Monroeville, especially at Westinghouse.

Today there are Hindu and Sikh temples, a Muslim center and a Korean church, in addition to places of worship for Protestant, Byzantine and Roman Catholic, Orthodox and Jewish residents. There are Indian, Pakistani, Italian, Mexican and Asian stores and restaurants to serve the varied populations.

The diverse mix of races and religions today add cultural flavor to Monroeville's melting pot—something even the best researchers may not have considered in the formula.

PART V
THAT'S ENTERTAINMENT

An Amusement Park's Rollercoaster Ride

Trolley parks dotted the Pittsburgh landscape from the end of the nineteenth century through World War I. They originated when trolley owners capitalized on off-transit hours by luring people from the smoke and dust of the local mill towns to the more pristine air of the countryside.

With the automobile's growth in popularity through the 1920s, savvy entrepreneurs updated the idea, creating a new wave of amusement parks catering to the emerging automobile culture. When William Penn Highway, also known as U.S. Route 22, opened through Patton Township in 1926, brothers John T. and Thomas P. Burke decided that a 444-acre parcel that spread along a mile of the new highway was perfect for such a venture. They opened Burke Glen Amusement Park in 1930.

Advertisements touted the new park as "the Seashore at Your Door." No one could argue that claim, even though the park sat far inland from the shore in western Pennsylvania. The amusement park had a one-thousand-foot covered boardwalk built over a natural creek that led to its various attractions. The creek not only added coolness to the boardwalk, but also provided the sounds of running water to the promenade.

A large above-ground swimming pool, filled with sparkling, filtered well water, offered springboards for the daring and slides and floats for the "shallow water bather." A large strip of land between the highway and boardwalk provided free parking space for the park's attendees, which sometimes reached the five-thousand-person capacity, and room for bus arrivals and departures.

Though some sources claim that the park opened as early as 1926, a story by Charles Wood in the November 1930 *Amusement Park Management* magazine makes it apparent that the park opened for its first season in 1930. Wood called

Remembering Monroeville

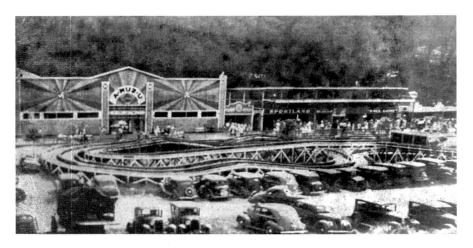

Burke Glen, the township's amusement park, offered rides, games and picnic spots. *Courtesy Monroeville Historical Society.*

Burke Glen "an experiment in attracting patrons who reach the park by auto and bus only, no streetcars or trains." The park was only seven miles from the Pittsburgh city line and twelve miles from downtown but drew from the nearby towns of Wilkinsburg, Pitcairn, Turtle Creek, Wilmerding and other surrounding rural areas. Its closest competitor was Rainbow Gardens, a similar automobile-based park with a rollercoaster and pool in nearby White Oak.

The park maintained a booking office on Liberty Avenue in Pittsburgh to serve potential and existing customers for the buses hired by the park's first manager, James Trimble. His idea was to bring patrons to the park during off-peak traffic hours, thus doing away with the exorbitant prices of peak fares.

In its heyday, the park offered many amusements and rides—a monkey cage, Chair-o-Plane, the Turtle, circle swing, fun house, carousel, miniature rides for the tiniest tots, auto rides, game stands, pony rides and the mammoth Speed Hound, one of the early roller coasters designed by one of the nation's foremost park engineers, John A. Miller. Universal tickets were sold in five-cent units in booths along the boardwalk. The concrete-block comfort stations were "clean and most sanitary," according to Wood's description, and had a tile interior and the latest in toilet facilities, though at that time no sanitary sewers served the township.

An eighteen-hole golf course with enlarged greens and splendid fairways provided another leisure time activity within the park. The athletic field boasted showers for the athletes and sheltered stands for spectators. Trees, playgrounds, stones, shelters, a creek and tables provided a picturesque

From Frontier to Boomtown

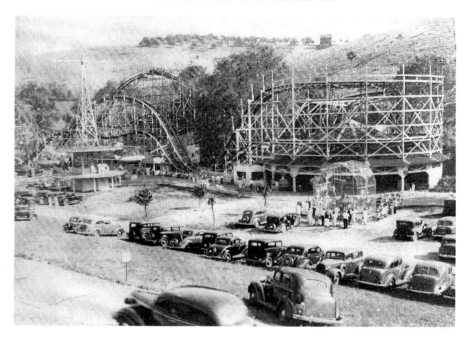

The Speed Hound rollercoaster attracted visitors to Burke Glen. *Courtesy Monroeville Historical Society.*

setting for family picnics. A picnic pavilion stood over the other amusements like a deck to save space and provided a view of the surrounding hills—as well as a country breeze. For those who opted not to go picnicking, the park provided many refreshment stands. Despite all of the other park attractions, one of the beverages caught the attention of Wood:

> *By the way, there are no coffee urns in this park. Here is another new thing as far as amusement parks are concerned. The coffee is made in a glass percolator, as in the better class drug stores, thus giving every customer a fresh cup of coffee and not coffee that has been standing in an urn. The upper glass globe is filled with coffee and the lower globe with water, which, when it boils, goes up through the stem into the upper globe and percolates. Individual cream pitchers are served with each cup. This coffee is rapidly becoming famous among Pittsburgh picnickers and park patrons.*

Burke Glen was also known for dancing. Dances were held in a cool, open-air pavilion and also in a dance hall. One advertisement beckons with free dancing, five-cent music boxes and "real large dance floors." The park

> **DONKEY BASEBALL GAMES**
>
> FREE EVERY SUNDAY
>
> We invite Soft Ball Teams to test their ability riding real live donkeys from Mexico. Apply at Park Office.
>
> LAUGHS - THRILLS - SPILLS - ACTION
>
> **Free Dancing**
>
> Real Large Dance Floors
>
> 5c MUSIC BOXES
>
> **BurkeGlenPark**
>
> U.S. 22 - 7 Miles East of Pittsburgh - City Line

A flyer advertised Donkey Ball at Burke Glen. *Courtesy Monroeville Historical Society.*

had square and round dancing on Fridays from 8:00 to 11:00 p.m., featuring radio and hillbilly bands. Admission was fifty cents for Saturday night dances. The park enticed people with other offerings as well, such as free Donkey Baseball games on Sundays.

No one, particularly the Burke brothers, was laughing a decade later when, on November 14, 1940, Pennsylvania governor Arthur Horace James approved a plan for relocating, changing and grading William Penn Highway. The roadwork totally destroyed the essence of the amusement park. John and Thomas Burke filed a claim against the state, saying that the park's value was lost, along with the buildings, pipes and springs they maintained. They appealed the $39,872 offered them by a Board of Viewers to Allegheny County Common Pleas Court, asking for $350,000 in damages. A jury awarded them only $80,000. Gas rationing during World War II did nothing to help bring more customers to the park.

From Frontier to Boomtown

The brothers continued to operate the park through the 1940s. After that, others leased the land. The Mathews family of Turtle Creek ran the park in the 1950s, and then Bill Duckworth of Bethel Park took over in the 1960s, renaming the attraction Cool Springs. By the 1970s, when Leo West of Penn Hills operated the park under the Summer Fun Inc. name, only a miniature golf course, driving range, picnic area and pool remained.

In their estate, the Burkes bequeathed the land on which the park was located to the Catholic diocese of Pittsburgh, which oversaw the lessees.

In 1974, West wrote a letter to the diocese, explaining that it was impossible to continue to operate Burke Glen. The last three seasons had been unprofitable, and the park faced costly improvements in order to continue. West anticipated less than $400 in picnic reservation revenues, the miniature golf course needed new carpets and the Allegheny County Health Department mandated improvements to the pool and refreshment stand.

The park did have a few dances left. A nightclub, Flip's Electric Banana, operated in the dance hall in the years just before the park closed.

In the 1970s, the diocese sold the property to Center Associates, a group of developers that used the site as a shopping center. Another part of the property became an auto dealership.

Today, motorists traveling Route 22 can see the vestiges of the driving range, all that remains of what was once Burke Glen.

The Roadhouse

Since the days of Martha Miers's Wayside Inn and Abraham Taylor's Rising Star Inn, the area that encompasses what was and is Monroeville has always been a place where visitors have been welcome to have a meal or stay the night.

Through the years, the concept of the roadhouse developed from a country inn that provided room and board for visitors to an all-inclusive description of restaurants, hotels and motels. One such roadhouse that has survived more than eighty years and two makeovers is LaBarbe, located on Old William Penn Highway. LaBarbe, as the name implies, started as a roadside barbecue stand in 1926, opened by Allan Behler, then principal of Turtle Creek High School. LaBarbe was Patton Township's first fast-food establishment, built at a cost of $1,500.00. The first day in business on the first William Penn Highway (U.S. Route 22), the open-air stand made $3.40 and only $12.60 on the second day.

Even without today's quick communications devices like e-mail, text messages and Twitter, by the third day word had spread about the food. Behler

Remembering Monroeville

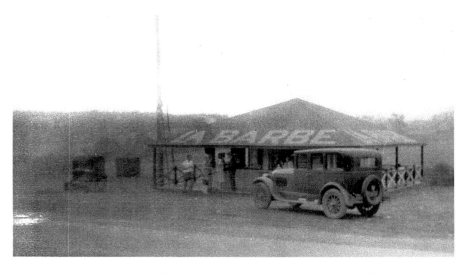

LaBarbe, when it opened in 1926 along the first Route 22. *Courtesy Monroeville Historical Society.*

brought in $182 that day. To put the sales into perspective, barbecue meals were only ten cents, and soda pop and candy five cents each. Small suckling pigs were roasted outdoors on a barbecue spit. But they weren't drenched in the tomato-based red sauce we often equate with today's barbecue meats. Barbecue referred to the cooking process. Though the spit is long gone, the tasty shredded pork and relish sandwich, "cooked in its natural juices and served on a steamed bun," remains on the restaurant's menu today, prompting waitresses to inform newcomers not to expect a saucy sandwich.

Three years after opening, the stand was enclosed by windows. Eventually, a full-scale restaurant replaced the original structure. The neon "LaBarbe" lights beckoned travelers along the highway.

LaBarbe's popularity grew, drawing people in from throughout the region, especially after adding an outdoor dance floor out back in the 1950s, enabling the restaurant to advertise "dancing under the stars." The concert stage provided big-band entertainment, including the famous Lawrence Welk band. Welk and Behler became close friends through the bandmaster's many trips to the Pittsburgh area. As a gesture of friendship, Welk presented Behler with an engraved cigarette case in the form of an accordion.

Weather problems caused the dance floor to be torn down. In 1973, the roadhouse was put up for sale, and major chain restaurants expressed an interest in the property. But Behler wanted the restaurant to retain its identity, so he sold it John and Mary Ann Malay of Penn Hills.

From Frontier to Boomtown

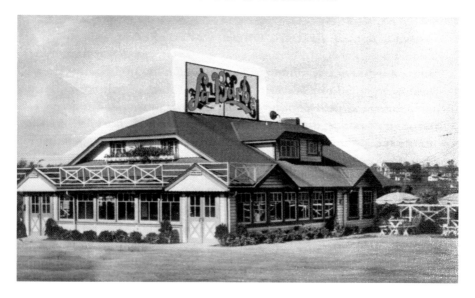

LaBarbe, as it looked in the mid-1950s. *Courtesy Monroeville Historical Society.*

One year later, fire broke out in the second-floor apartment over the restaurant, destroying the building. While the new restaurant is brick, it retains the homey feel that Behler hoped to pass on.

Of course, LaBarbe wasn't the only establishment that fit the roadhouse bill along what is now Old William Penn Highway. Across the street, Joe and Tony Borowiec operated the Sportsman's Bar in a house during the 1940s. The house also was used as a meat market and sandwich shop before it was torn down and replaced by a gas station.

During Prohibition, which lasted from 1919 until 1933, the underworld controlled the liquor sources. Where Haymaker Road intersected the first Route 22, two speakeasies opened on opposite corners. The Pok-a-dot Club was owned by Red Statz and sons, who converted an old home into a bar by painting large dots on the exterior, giving the club its name. The bar was located on the corner where Good Shepherd Lutheran Church stands today. The Hi-Hat Club, owned by brothers Harry and Gerald McMasters, was more of a night club, offering dining and dancing in a more refined atmosphere on the opposite corner.

Another popular club was the Locust Post, at the corner of Beatty and Haymaker Roads, where Jobe (Gene Van Horn) Funeral Home stands today. The club had only a dance floor and a snack bar that served liquor. The place was raided once by federal agents, but the club survived until a

murder victim was found there. Another club, Red Crystal's, was located on Stroschein Road, near the entrance to Miracle Mile Shopping Center. Mr. Crystal worked for Cunningham Coal Co. and had a commissary-type restaurant for immigrant coal workers.

After Prohibition was repealed, the clubs eventually disappeared.

In the late 1930s, Tucker's Hotel was built from used material on the old Duff Farm, near the corner of the Duff Road and William Penn Highway. During World War II, the Pennsylvania and Union Railroads brought Mexican immigrants as laborers to replace the American workers who went to war. A barrack was built behind the hotel to house them, and the immigrants ate either at the hotel or a diner built in front of it. When the barrack was torn down after the war, the hotel changed its name to Red Coach Inn.

Cole's Cottage Restaurant opened at the corner of William Penn Highway and Stroschein Road in 1943. Beatty's Restaurant was just a bit west on Route 22.

The Mexican hat sign on the San Juan Motel made it a landmark location along Route 22 in the 1950s. When it was sold, the property was used to create Jonnet Plaza, one of the many Route 22 shopping centers.

Along William Penn Highway, two establishments have remained since the 1950s—Esta Esta, a family-owned Italian restaurant and bar, and the Penn-Monroe Lounge, also a family-run operation. Al Monzo opened his hotel in 1973 as a Howard Johnston's but changed the name to the Palace Inn, offering food, dancing in a huge ballroom and entertainment in addition to lodging.

As Old William Penn Highway became less traveled, and William Penn Highway's mom and pop road restaurants and motels gave way to franchises and chains, establishments with character began to disappear.

On the Garden City section of Old William Penn Highway, Ed's became one of the many small establishments along the nation's first highways to offer individual tourist cabins for lodging. By the 1970s, local residents had dubbed the place "Ed's Beds"—a place where romantic couples could find a room—but often not for the whole night.

The Monroeville Convention Visitors Bureau was established to promote local tourism. Today's hotels and restaurants provide the same function as the earliest roadhouses—feeding travelers, putting them up for the night and making them feel welcome.

From Frontier to Boomtown

Going, Going, Sold

"Twenny-now-twennyfibe-now-fibe-wiyagimmie-twennyfibe-now-thirdy... who'll make it thirdy? Get it like you got your wife, for better or worse."

Television has encouraged families to become couch potatoes, but in the days before that, entertainment in Monroeville came from churches, community events, schools or, in the post–World War II years, a place known as Joe Taylor's Auction Barn.

Joe Taylor, who some called a born horse trader, decided to do just that. With $750 in hand, he decided to take a gamble that a weekly auction would pay off. In 1946, he took all the money he had and his experience in auctioning livestock and opened William Penn Auction Inc., on what is now the corner of Business Route 22 and Route 48, where the Parkway East exit ramps loop around.

He bought a farmhouse and a barn and invited area farmers to offer livestock. Eventually, machinery and general merchandise were also auctioned. The prices the farmers got surprised them—and brought them back, as well as buyers eager for specific animals or items or those who came

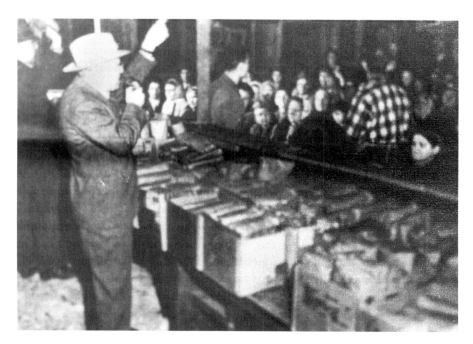

Joe Taylor entices potential buyers at his Auction Barn. *Courtesy Monroeville Historical Society.*

for the fun of seeing what deals they could take home. Taylor's notion to capitalize on the gambling instincts of those people who like to buy and sell at auctions began to pay off.

Business grew quickly, so Taylor bought seventeen more acres of land and enlarged the barn. And soon, Taylor was doing an annual business of $1 million. The auction barn covered an acre itself, and eighteen employees were needed to keep the business running with three weekly auctions.

Each day brought a different crowd, everyone from farmers and merchants to housewives and teenagers. Wednesdays were the day for selling cattle, butter and eggs. Thursday evenings featured horses and ponies on the auction block. Saturdays, though, were open to any and everything. One week, it might be a box of two hundred right-handed gloves, the next week, coffin hinges.

Three auctioneers at a time were needed for the weekend sales, where crowds of up to five thousand people were common. One auctioneer handled miscellaneous items while a second coaxed bids on 1,200 packages of dressed meats ranging from T-bone steaks to pork loins. A packinghouse found it profitable to sell meat at auction, so the auctioneer gave potential buyers a description of the type of meat and its weight and then pushed the price up until only the top bidder remained. The third auctioneer specialized in selling only new merchandise.

The atmosphere was carnival-like, with vendors hawking hot dogs and drinks amid the chants of the auctioneers. Each auctioneer had a unique style used to cajole bids upward and provide a show for youngsters, oldsters and everyone in between. One vendor with a penchant for petite penmanship sold grains of rice with the customer's name written on them, one of the more unique items offered at the Auction Barn.

In the 1940s and into the 1950s, the Auction Barn provided something to do in rural Patton Township. Not everyone who came, though, had a farm or needed to buy or sell livestock or dairy products. Ella Ridgeway, a Turtle Creek native who later moved to Monroeville, recalls buying a box of cups one night for one dollar. Nor was everyone from the Patton Township area. The Auction Barn brought people in from throughout southwestern Pennsylvania and even neighboring states.

The Auction Barn bowed out before the suburb of Monroeville exploded with development. State plans for the Parkway East extension from Churchill Borough to Monroeville included two loops through the Taylor property.

Joe Taylor was the first to prove that Monroeville's location was its best asset when it came to bringing in people to spend their money. Though the Auction Barn suited the needs of a rural community, the crowds it

From Frontier to Boomtown

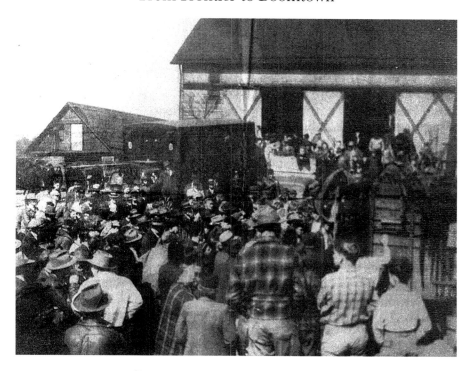

The Auction Barn even drew people from neighboring states. *Courtesy Monroeville Historical Society.*

drew provided an eerie foreshadowing for the retail community that would overtake the highway just a decade later.

Cruisin' the Miracle Mile

About the beginning of the twentieth century, Dan McMaster owned a farm with a beautiful grove at the corner of what now is William Penn Highway (Business Route 22) and Stroschein Road. The corner became a popular picnic area, especially during Old Home Week, when people came from miles around for the annual Harvest Homecoming picnic, one of the largest social gatherings of the year.

Men in suits and women in their finest shirtwaists arrived with their picnic baskets full of tasty foods like pickled eggs, piccalilli, baked beans, sandwiches, homemade root beer and apple pie. They would spread a large blanket on the ground and spend the day conversing with friends and family in the idyllic respite that the grove provided.

Remembering Monroeville

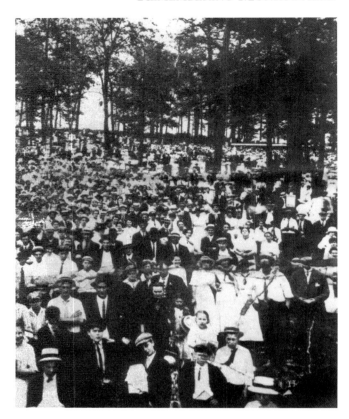

McMaster's Grove drew hundreds each year for the annual Harvest Homecoming Picnic in the early 1900s. *Courtesy Monroeville Historical Society.*

There was something more valuable on that corner that chased away the picnickers more quickly than a swarm of ants. During World War I, laborers and machines strip-mined the ancient surface coal, but they created a barren, forlorn corner after felling beautiful trees and leaving behind ugly, upturned sod.

The land was vacant for more than two decades, a large portion of it covered with slag piles, pit holes and red dog gravel. About 1947, Patton Township school directors were in a quandary. Faced with the prospect of having to provide another school instead of sending students to neighboring districts and paying tuition, they decided to risk the anger of a taxpayers' league unsympathetic to the cause and purchased thirty acres of land at the corner for $15,000—even though they had no money to build the school at the time. Still, they began grading the land in preparation for the day a school could be built.

A bulldozer uncovered a vein of coal that had been missed, and the $6,500 the school district received from coal royalties helped defray the $30,000 in

From Frontier to Boomtown

grading costs. By that time, though, the location had become unsuitable for a school. The Parkway East had been completed as far as Churchill Borough, dumping traffic onto William Penn Highway through the township. The post–World War II baby boom brought Pittsburgh residents to the developing suburbs, and the Pennsylvania Turnpike threatened to feed even more traffic onto Route 22, making it inevitable that the road would have to become a four-lane highway. Seeing the potential for an unsafe situation with more cars using the roadway, the school board saw the writing on the chalkboard and decided to cancel its plans.

However, that traffic was something that was desirable to two Ohio-based developers—the Don M. Casto Organization and the Joseph Skilken Organization, which together built Southland, Northern Lights and Great Southern shopping centers, some of the Pittsburgh area's earliest and largest centers of retail commerce. Willing to gamble on the property's potential, the developers paid the school district $165,000 for the land to create what would become the largest shopping center between New York and Chicago.

At the time, Route 22 was relatively undeveloped. The rapid growth of the area, as well as its strategic location on the highway between the parkway and turnpike, made it the perfect site for the area's first suburban shopping center. The business plan was to draw customers tired of feeding city parking meters and paying for parking garages or lots.

The developers broke ground on November 9, 1953, promising nearly 2,600 parking spaces on a concrete concourse and twenty-five stores ranging from eateries to five-and-tens. The $10 million, 300,000-square-foot Miracle Mile Shopping Center opened a year later on November 4, 1954.

Miracle Mile was a misnomer to some degree. Though it fronted on only about a fifth of a mile along William Penn Highway, it approximately affected the next four miles of the road between the parkway and turnpike, which soon developed into the busiest commercial corridor in Pittsburgh's East Suburbs.

The original anchor stores included two five-and-tens—Woolworth's and S.S. Kresge—as well as two traditional, moderately priced family department stores, J.C. Penney Co. and Sears. Sun Drug was located at one end of the strip and Thrift Drugs at the other. Kroger and Star Market competed as supermarkets.

The early stores offered shoppers nearly everything that a suburban family needed. Whitehead Hardware, Pittsburgh National Bank, Faller's Furniture and Knabe Sports and Garden Center were among the early stores, as were Standard Sportswear, Richman Bros, A.S. Beck Shoes, Kinney Shoes, Isaly's, Loreski's Hobby Store, Dormont Tire Co., Olan Mills and a number of men's and women's stores.

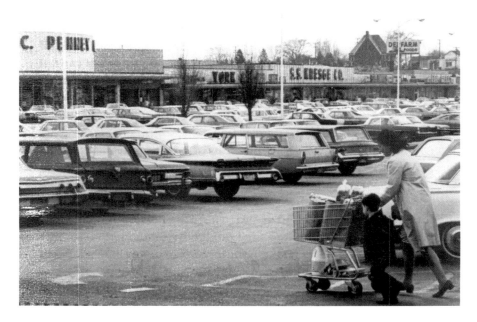

Miracle Mile Shopping Center drew shoppers away from local towns. *Courtesy Monroeville Historical Society.*

One of the original tenants was the late Mel Pollock, who had Tweens & Teens, one of the first junior fashion shops, and Young Fashions for children. Pollock was from Gallitzen, a depressed coal mining town in central Pennsylvania where his father had a general merchandise store. While driving his wife along Route 22 to the airport in Pittsburgh, he spotted a sign seeking tenants for the new shopping center.

It was the 1950s and, in Pollock's words, "There were tons and tons of children." So he wanted to open a business catering to that age group. He met with Don Casto Sr., one of the developers, who showed him aerial photographs of where the shopping center was being built. Pollock saw a rural community with a relatively undeveloped highway bisecting it and asked Casto where the people were. Casto told him, "'When we build, there will be houses everywhere.' He sounded like a carnival barker."

Casto wasn't selling snake oil. During the first weekend of business, Pollock ran out of dresses because customers were literally coming out of the hills.

Like Pollock's, many of the early stores were mom and pop ventures intermixed with the larger chain stores. The shopping center had the potential for forty to fifty stores, most long and narrow like a bowling alley. Over time, as owners desired more of a storefront, spaces were combined.

From Frontier to Boomtown

There was also an arcade, which housed different businesses over the years. It closed during the 1990s when the center was remodeled to create a large store in the corner of the L-shaped structure.

The shopping center's store owners formed Miracle Mile Merchants Association, which sponsored outdoor promotions like fish ponds and animal acts to attract customers. Saturday nights were like a scene from the movie *American Graffiti* as young men and women filled their cars and cruised Route 22 between Miracle Mile and Eat 'n Park's carhop restaurant at the corner of Northern Pike.

Tenants changed as Monroeville experienced a commercial boom along William Penn Highway. A short time after Miracle Mile opened, Star Market was replaced by Loblaw's, then Del Farm Foods, then Foodland. Kroger supermarket disappeared after a strike in the 1980s. Early on, Sears moved down the highway to its own location in Penn Center, Wilkins Township.

The biggest blow came in 1969, when Monroeville Mall opened down the highway. J.C. Penney relocated to the mall, along with Richman Bros. and Beck's Shoes. Business at the shopping center plummeted and Casto-Skilken even reduced the rent for a short period to help its merchants recover from their losses.

In the 1970s, Casto-Skilken began developing outparcels for restaurants. According to statistics compiled by the United States Census Bureau, the shopping center's forty-five stores were generating an annual retail sales volume of $20 million by 1975.

Chain stores replaced the smaller, family-owned businesses, including Pollock's one remaining store, Young Fashions. When Pollock held his going-out-of-business sale in 1984, the crowd was so great that he had to station a policeman at the door to let in only twenty customers at a time. Pollock sold out of everything, including a soiled Christening dress that a man purchased for one dollar—the last sale.

In the mid-1980s, the shopping center got a face lift to make it look more modern. Casto-Skilken built two office buildings, Corporate One and Two Office Park, at the rear of the stores. Of the original twenty-five tenants, only the state liquor store remains.

Despite competition up and down the highway, Miracle Mile is still a thriving shopping center that has few vacancies. After more than a half-century of ownership, Casto-Skilken sold the shopping center to Oakmont Properties, LLC, in 2005.

The one major draw today is the same one that the developers gambled on in the 1950s—"location, location, location."

Holiday House: Where the Stars Came to Shine

With Monroeville growing as a transportation and commercial hub, the time was ripe to make it a destination. Nothing did that better than the Holiday House, a supper club and hotel that opened on October 10, 1955.

The Holiday House brought in top acts and was billed as "the Nation's Finest Supper Club and Motel." Its owner, John Bertera Sr., a one-time grocer who operated the Vogue Terrace Lounge in East McKeesport, had the magic touch in choosing stars to bring in the crowds—and the formula for success. Guests could get a full meal and a show for $12.95 and then move to the lounge and dance until closing.

Built at a cost of $250,000 on a former used car lot, the original structure included a nightclub and motel with twelve rooms. By 1979, not including periodic face-lifts, there were seven major additions that included 190 new motel rooms, a swimming pool, disco, coffee shop, expanded parking lot and five large banquet rooms that served about 150,000 people per year for proms, weddings and other gatherings. The supper club's main room seated one thousand people. With two shows a night, about fifty waitresses were kept on their feet as they hustled to reset that many place settings and first courses in the few minutes between the 8:00 and 10:00 p.m. shows.

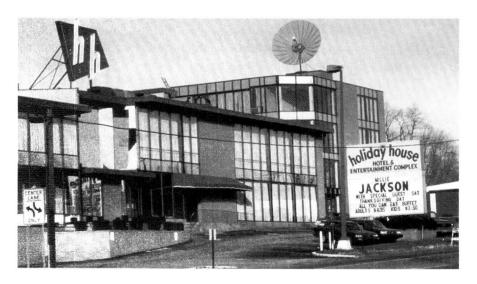

The Holiday House had Atlantic City–style entertainment. *Courtesy Monroeville Historical Society.*

From Frontier to Boomtown

The opening act in 1955 was Eileen Barton, whose big hit was "If I Knew You Were Coming I'd Have Baked a Cake."

During the 1950s and 1960s, the Holiday House had competition from other area supper clubs, including the Twin Coaches in Rostraver Township and the Town House, which was also on Route 22 in Monroeville. But the Twin Coaches burned down and the others faded away, leaving the Holiday House as the premier entertainment venue in the Pittsburgh area.

It would be impossible to name all of the acts that appeared on the stage. But among them were vaudevillian Sophie Tucker; vocalists Frank Sinatra, Sammie Davis Jr., Robert Goulet, Bobby Vinton, Billy Eckstine, Lou Rawls, Sonny & Cher, Pat Boone, Debby Boone, the Beach Boys and Kenny Rogers; comedians Milton Berle and Joey Bishop; Motown legends Smokey Robinson and the Temptations; jazz legend Benny Goodman; pianist Liberace; 1940s screen legend Dorothy Lamour; and 1970s rock/jazz group Blood, Sweat and Tears.

People came to hear Three Dog Night, the Four Lads, the Four Seasons, the Four Freshmen and the 5th Dimension. Local entertainers like singer Jill Corey, comedian Marty Allen and the Vogues, a 1960s chart-topping vocal group from Turtle Creek, broke into the big time at the Holiday House.

One of the most memorable performances was given by singer Wayne Newton. When the building had to be evacuated because of a fire, Newton continued his show from the parking lot. After being knifed in Cleveland during a show, singer Jackie Wilson took the stage with seven gun-toting bodyguards.

By the late 1970s, Bertera had grown his business into a convention and seminar headquarters and even had business tenants who were offered modern space in a complex where they could entertain their clients with both food and shows. The three main attractions were the main room; Tullio B's, a coffeehouse and buffet named for Bertera's father; and the lounge, which had a dance floor. Locals recall the disco, the Sunday brunch and the comedy club as the other draws.

By 1982, Bertera, who lived on site, had been trying to unload the Holiday House for some time. He was sixty-five years old, very successful and wanted to retire. Holiday House was in danger of shutting down. A buyer was found, and there would be a show, but not the kind that was entertaining.

Bertera's Holiday House began to vanish on March 24, 1982, when Sokol, who was co-owner, vice-president and Bertera's son-in-law, announced that the complex was being sold to Dr. Conrad Matz, a Monroeville chiropractor, and Richard Shumaker, an Irwin businessman. The final sale in April 1982 was for $6.5 million, with a $5 million mortgage held by Bertera through the

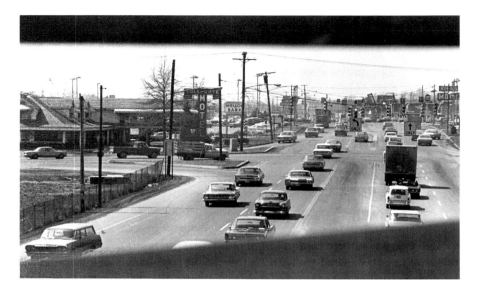

By the 1960s, those headed to the famed Holiday House encountered Route 22 traffic. *Courtesy Monroeville Historical Society.*

Allegheny County Redevelopment Authority. The duo promised to continue operations with no loss of jobs.

By November 1983, there were signs of trouble. The Holiday House was searching for people willing to invest $10,000 increments into the establishment in hopes of raising $1 million. Shumaker filed for bankruptcy and Matz, who had put up the money to purchase the eleven-acre complex, contested the court proceedings.

Entertainment Enterprises, a partnership between Bertera's sons, John and Robert Bertera, and some other investors, tried to purchase the floundering club from Matz-Shumaker, but a federal judge struck the deal down. However, U.S. Bankruptcy Court judge Joseph Cosetti approved a management agreement between the partnership and the court trustee in May 1984 that let Entertainment Enterprises try to save the club.

Bertera's company, Holiday House Inc., went to common pleas court to try to recoup some of the money owed. Matz filed a petition claiming that the Holiday House had a "grossly exaggerated appraisal of the business and assets," misled him about the profitability and financial condition of the club and failed to tell him that attendance had dropped 50 percent over the seven years before 1982.

Evidently, aging audiences, singers without a hit for a few decades who were unknown to younger audiences and other opportunities for entertainment

had begun to take a toll. Unfortunately, the headliners and nightclub itself pulled in drug dealers and crime from surrounding areas. A shootout during the mid-1980s involving three men made patrons feel unsafe.

There were others drawn to the Holiday House—members of the federal Organized Crime Drug Enforcement Task Force investigating Michael J. Genovese, head of Pittsburgh's La Cosa Nostra. Genovese ran a criminal empire from behind the scenes—and often over meals at the Holiday House, which became a favorite Mafia hangout. Genovese built the Pittsburgh mob into Pennsylvania's strongest family before the task force took down his second and third in command and seven associates in 1990.

Robert Bertera headed Entertainment Enterprises, which finally bought the club at a bankruptcy sale in March 1984 for $5,000 and an agreement to pay a $5.9 million industrial development authority mortgage. The club's reprieve was short-lived. By May 1988, Oxford Development Corp., which owned Monroeville Mall, purchased the complex for the site of a new strip shopping center.

The final show was June 18, 1988. The building was razed in January 1989. The shopping center was named Holiday Center, a tribute to the well-known landmark.

Dawn of the Mall

Miracle Mile Shopping Center helped to trigger Monroeville's evolution into a hub of retail shopping. Soon after, there was some competition from nearby Eastland Shopping Center in North Versailles and East Hills Shopping Center, located on a parcel that crossed the boundary lines of Pittsburgh, Penn Hills and Wilkinsburg.

These shopping centers with their chain stores began to pull customers away from the family-run businesses in the downtown Main Street shopping centers of neighboring towns like Pitcairn, Wilmerding, Turtle Creek, Wilkinsburg and Braddock, where Monroeville residents had always shopped.

By the 1960s, though, shoppers were becoming more sophisticated, mothers were reentering the workforce as their baby boomers grew older and those baby boomers were starting to earn their own money to spend. There was a new trend in shopping across the country—the indoor mall—and with its location and the already-established commercial zone, Monroeville was a perfect site for one.

Prime property was growing short along the four-mile stretch of Business Route 22, but there was a piece of land, known as Harper's Mine, that

caught the eye of Don-Mark Realty. The parcel was far from prime, though it would provide access to and from William Penn Highway. The land was fronted on the highway by Luzader's auto center and the 22 Motel. Not only was there a former coal mine on the site, but there were also three hills and some areas of subsidence. Some of the land around the deep ravine was 1,200 feet high. The developers had to push dirt into it to create a flat enough pad on which to build the mall.

The advantages of the property outweighed the disadvantages for the principals in the $30 million development—Donald Soffer, Edward Lewis, Harry Soffer, Eugene Liebowitz and Mark Mason. Don-Mark Realty had already developed South Hills Village, at the time the largest enclosed mall between New York and Chicago. Monroeville Mall was designed to be 20 percent larger.

More than five million cubic yards of dirt had to be moved to level the mall site. At the time the mall opened, information provided by the developer indicated that excavation costs alone totaled $2.5 million. Construction began in 1967 on the 1.3-million-square-foot Monroeville Mall on 110 acres of the 280-acre tract. The parking lot was designed to hold 6,500 cars.

The mall opened its doors in 1969 with 125 stores on two levels and a world-class ice rink at its center. J.C. Penney moved from Miracle Mile Shopping Center to occupy the center anchor position, and two other major department stores, Joseph Horne Co. and Gimbels, secured the two ends of the mall. G.C. Murphy's, the mall's only five-and-ten, provided a lower-price alternative on the lower level of the structure.

The mall provided atmosphere that an outdoor shopping center could not. Tropical plants and trees flourished under skylights that allowed natural light and helped with temperature control. The Gimbels court featured a clock tower with twelve puppets, three on each side, that each represented one of Pittsburgh's ethnic groups. One puppet performed each hour, with all twelve in action at 1:00 and 6:00 p.m. The court at the Horne's end had a large, circular fountain surrounded by a low wall that enabled mall patrons to pause for a relaxing moment as they shopped.

Initially, the mall was more of a one-stop shopping trip than it is today. Among the first stores were Wayne-Weil carpets, Vecchio's Red Carpet Barber Shop, the Fabric Tree, Bandy Office Supply, Leonard's Draperies, Ryan Homes, National Record Mart, Uniforms East, Wig World, Toyco, Welcome Aboard Vacation Center, Fashion Hosiery Shops, Docktor Pet Center and Biggs, a house wares and hardware store. Singer Co. offered sewing machines, and Reizensteins sold crystal, silver and china.

From Frontier to Boomtown

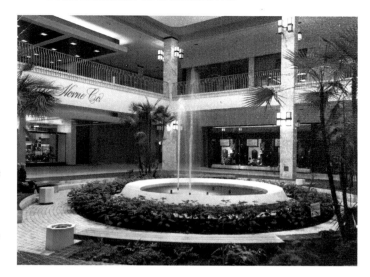

The fountain in the Joseph Horne Co. courtyard provided a welcome respite from shopping. *Courtesy Monroeville Historical Society.*

The mall was home to several jewelry stores and a variety of specialty shops for men, women, teens and children, including the Tweed Shop, Junior Shoe World, Standard Sportswear, Miller's Fashions and Hughes and Hatcher men's wear. Reflecting the times, one of those stores, Ormonds, advertised "super groovy clothes for the mini-budget."

With the 1960s counterculture at its peak, A Shop Called East sold incense, ivory and teakwood items, which fascinated teenagers but raised the eyebrows of parents who weren't quite sure about exactly what the place sold.

Today's shoppers would be surprised by how far a dollar went then. Penney's had men's suits on sale for $47.88, and Murphy's sold two boys' shirts for $3.00, panty hose for $0.78 a pair, three women's panties for $0.84, stereo albums for $0.94 and top 40 pop 45rpm records for two for $1.00.

Mall shoppers never had to worry about being hungry. Those who wanted to grab a quick bite could find a hot dog at the Pup-a-Go-Go refreshment stand, an ice cream cone at Isaly's or a cup of coffee at Daisy Donuts. There was a fine dining ice rink at Schrafft's or more moderately priced fare at Sweet William's Restaurant, Belle's Restaurant and Delicatessen, Monroeville Mall Pub or G.C. Murphy's cafeteria. Penney's coffeehouse/restaurant, located in the store, offered an opening special of roast turkey with dressing, potatoes, peas and rolls for $1.19 and fresh strawberry pie for $0.40. Rhea's Bakery, Fannie Farmer and Barricini Candy satisfied the sweet tooth of many a shopper.

Once the mall was fully operational and drawing droves of customers, development began at the perimeters of the complex. Gimbels and Penney's

both opened auto centers at the rear of the mall. A mall annex, also at the rear, housed an A&P Supermarket, Peking Restaurant, a state liquor store and Tom's Butcher Blok. Other early annex tenants were Mall Beverage Center, Moio's Italian Pastry Shop, Mall Newsroom, Belmar Candy, U.S. Post Office, Mall Cleaner, PPG Decorating Center and Kubrick Bros. Garden Center.

Sheraton Inn on the Mall opened on undeveloped property between the mall and Route 22. Shop 'n Save supermarket and Kmart were located in a separate building near the hotel. Next to them, Greater Pittsburgh Merchandise Mart was built as a facility for manufacturers' representatives to display their goods. The Racquet Club opened on the hill above the merchandise mart, followed by the luxury Racquet Club apartments. By the 1980s, the merchandise mart had outgrown its usefulness. In 1981, it was replaced by the $8.3 million Pittsburgh ExpoMart, designed to attract trade shows and exhibitions, as well as provide more space for Merchandise Mart tenants.

A movie theatre, Cinemette East, opened near the Gimbels end of the mall in the early 1970s. And the mall itself has offered entertainment to draw in shoppers over the years—singer Dionne Warwick; Hanson, the three-brother group that became teen heartthrobs in 2000; Monroeville Arts Council's Pops for Kids concerts; and numerous soap opera stars.

While Monroeville Mall will live on in local history, it also has a place in entertainment history. In 1978, director George A. Romero used the mall as the main setting for his low-budget zombie movie, *Dawn of the Dead*, which has become a cult classic. A sequel to his 1968 *Night of the Living Dead*, the movie follows four survivors of an expanding zombie apocalypse as they take refuge in an abandoned shopping mall.

The Internet Movie Database website notes that filming took place during the winter of 1976–77, except for three weeks during the Christmas shopping season because it would have been costly to nightly remove and replace all the seasonal decorations. Filming began about 10:00 p.m., shortly after the mall closed, and finished at 6:00 a.m.

Some of the actors playing zombies in the movie frequently drank at a late-night mall bar called the Brown Derby. One night, they stole a golf cart and crashed into a marble pillar, causing $7,000 in damages. Zombie actors also took photographs of themselves dressed up in full zombie makeup inside a photo booth on the second floor and then replaced the sample pictures on the front of the booth with the ghoulish ones.

Zombies returned to Monroeville Mall in 2006 when the locally produced *The It's Alive Show*, which features horror movies hosted by a

From Frontier to Boomtown

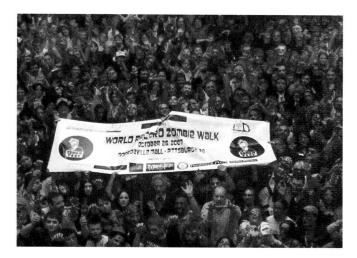

On October 26, 2006, the Zombie Walk at Monroeville Mall broke a Guinness World Record. *Photo courtesy Sandy Stuhlfire.*

cast of ghoulish characters, organized the first Zombie Walk at the mall to collect donations for the regional food bank and attempt to set the Guinness World Record for the world's largest zombie gathering. The first gathering has expanded into an annual Zombie fest with a Zombie ball, talks by horror authors and a zombie film festival. The gathering set the world record in 2006, 2007 and 2008.

A relatively newer mall store, Toy Galaxy, is home to the Monroeville Zombies exhibit, a visual history of zombies in cinema.

Movie director Kevin Smith filmed portions of his 2008 release, *Zack and Miri Make a Porno*, at Monroeville Mall. Unlike when Romero filmed, Smith actually requested that the mall management leave up its Christmas decorations into late February because the mall scenes were depicting the holiday shopping season. The movie was set in Monroeville, so in a tribute to the Romero classic, Smith chose the Monroeville Zombies for the name of the fictional hockey team in the movie.

On Thin Ice

When Monroeville Mall opened in 1969, it had at its center a glistening gem.

Monroeville Mall Ice Palace was the first full-sized ice arena in an East Coast shopping center and actually larger than the Rockefeller Plaza ice rink in New York City. The mall owners, Don-Mark Realty, saw the rink as a gift to the community, an amenity that would enable shoppers to take a break

and watch people having fun. The adage "Build it and they will come" was certainly true in the case of the Ice Palace.

Moms and kids showed up, and dads, too. Teenagers found it, as did senior citizens. Couples fell in love there. Skating clubs met there. Hockey teams won—and lost—there. The fifteen-thousand-square-foot rink drew the neighboring suburbanites at a time when skating was at its peak with the popularity of figure skaters Peggy Fleming, Dorothy Hamill and Janet Lynn, as well as pairs skaters JoJo Starbuck and Ken Shelley.

The Ice Palace wasn't just a random idea. Mall skating rinks were in vogue in the late 1960s, so the mall developers gave a lot of thought to creating it. George Lipchick, the first rink manager, was sent to every one of those mall rinks to see what was right, what was wrong and what Monroeville Mall could do better.

Lipchick, a professional skater, was chosen because he had worked at the South Park and Duquesne Garden rinks around Pittsburgh, trained at the Ice Capades school—and because he had studied to be a draftsman at West Penn Tech. That combination of talents enabled him to work with the architect to design a rink beyond compare.

Bob Mock, the second of two Ice Palace managers, remembers when he first saw the rink. "I thought the floor was marble. It was such a perfect piece of ice." From the day the rink opened until its final hour, people would bend to touch the ice, wondering if it were real or plastic.

At the entrance to the rink was Pup-a-Go-Go, a two-sided hot dog stand that provided concessions for both mall shoppers and skaters. But it was the mall and ice rink that fed off each other. The mall brought in impulse skaters who were out shopping, and the ice rink's hard-core skaters made the mall their place to shop. When merchants had ten-cent specials, a mob of kids would line up outside the rink to skate while their parents shopped.

In the beginning, only public and figure skating were offered at the Ice Palace. The Ice Palace figure skating school offered lessons for those wanting a more graceful sport. But by the 1970s, high schools, including Gateway High School, were starting competitive hockey clubs. By the mid-1970s, between hockey scrimmages and public sessions, the rink was in operation eighteen to twenty hours a day.

Not only did the Ice Palace draw skaters and hockey players, it drew the stars. When the Ice Capades or Ice Follies came to Pittsburgh for big shows at the Civic Arena, home of the Pittsburgh Penguins, they sent out small troupes to do a short exhibition at the mall.

The rink also drew prominent figure skaters, Pittsburgh sports figures and radio and television personalities. Steelers quarterback Terry Bradshaw

From Frontier to Boomtown

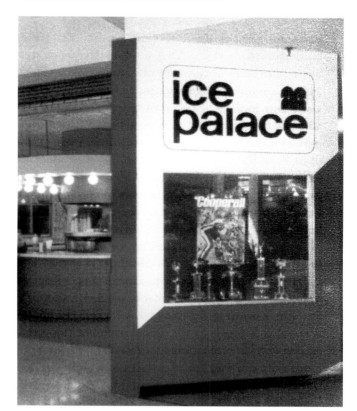

Right: Monroeville Mall Ice Palace was a cool place for young and old alike. At the entrance was Pup-a-Go-Go, a popular hot dog stand. *Courtesy Bob Mock.*

Below: The ice rink drew young hockey players—and the Pittsburgh Penguins, who practiced there. *Courtesy Bob Mock.*

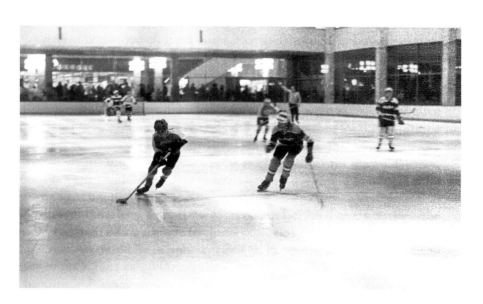

courted Olympic skater JoJo Starbuck at the Ice Palace, with hundreds of shoppers and diners looking on from the windows of the mall's top level. Schrafft's, the mall's only fine dining restaurant, sported an ice skating décor and continuous live entertainment as the skaters did axles and Salchows, the hockey players shot and scored and the smallest of tykes struggled and slipped as they learned to skate.

After a Super Bowl win, Bradshaw came to the Ice Palace to sign autographs for skaters. The crowd was so large that the quarterback had to be slipped in through a fire exit door.

The Ice Palace's Christmas show brought Santa to the mall—and often a behind-the-scenes story to tell. One year, the rink had rented costumes for Rudolph and eight reindeer, which would be portrayed by children. After the reindeer donned their costumes, there was a tale to be told. By mistake, the costume shop had sewn the tails on the front of the costumes, leaving dangling appendages in an inappropriate place. Scissors saved the day.

In a big year, the rink took in about $500,000, a significant income considering the $2 admission fee. About five thousand people came through the Ice Palace's doors every week. Liability insurance issues and a trend toward malls having food courts led to the end of the rink. The only logical place in the mall for a food court was the ice.

Regular skaters protested, but it was too late.

At the final public skate session, the song "Flashdance" played as members of the Pittsburgh Figure Skating Club made the final round. The goal of the regular skaters was to play the tune as the first song at a new rink.

The displaced skaters didn't have a meltdown. In fact, they heated up their effort to find another place to skate in the Monroeville area. The group had a commitment from Art Spagnol, who owned a former lumberyard at the corner of Routes 48 and 130, deemed a perfect location for a new facility. Monroeville Council rezoned the land, but Spagnol backed out. The group also had discussions about locating a rink next to the Monroeville Mall Annex and at the adjacent Racquet Club. Neither of those panned out, nor did relocating the rink to Eastland Mall in neighboring North Versailles. There was even talk of having an all-glass rink fronting on Business Route 22 at Miracle Mile Shopping Center.

Eventually, the effort led to Golden Mile Ice Rink, located on Old Frankstown Road along the Monroeville-Plum border. On opening day, the "Flashdance" lyrics—"take your passion, and make it happen"—spoke to the effort of the mall skaters as the first skaters hit the Golden Mile ice.

PART VI
IN THE END

Workin' in a Coal Mine

When the European settlers made their way westward into the Pittsburgh area, they found warmth and comfort in a friend from the Old Country—coal. They were not only familiar with the use of coal, but they were also able to detect its presence and abundance in the hills of western Pennsylvania.

Even the William Penn family recognized and appreciated the natural resource in their land. The Penn family's "Manor of Pittsburgh," their name for the property surveyed in 1769 that would become the city, sold the privilege of mining coal in the Great Seam to anyone who would pay thirty pounds for a mining lot.

William Scull, a mapmaker, indicated the presence of coal in the territory surrounding Pittsburgh in a survey he published in 1770. As settlers made their homes on the frontier, many discovered coal on their properties.

At first, coal was superficially mined from the surface veins with a pick and shovel. Because wood was plentiful and favored as a cheap, clean fuel, coal brought little money to those property owners who extracted it from their land. Over time, they mined deeper, carrying with them little miner's sconces made of wrought iron. On one end was a socket for a candle, on the other end a pricket that could be driven into the mine wall to support the light. One of these sconces was found in the bed of Turtle Creek, near its mouth, providing evidence of the early mining in the area around Monroeville.

By 1804, coal prospectors realized that there was a market for the area's bituminous coal in other areas of the state and country. Barges of coal were shipped downriver for inland distribution by wagons and canals. The loads on the barges had to be small so the barge could stay afloat. It wasn't until the advent of the railroads in the mid-1800s that the coal industry became firmly established. By the 1870s, coal branch railroad tracks were laid to

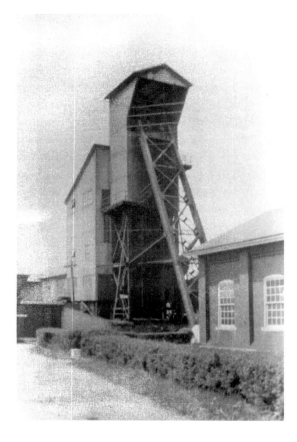

This coal tipple is typical of the ones that dotted the Patton Township landscape. *Courtesy Monroeville Historical Society.*

service the mines, as well as narrow-gauge tracks to haul the loads from coal mine to train line.

The first local mining efforts supported the colonial iron industry. But once Andrew Carnegie's steel mills began forging the industrial growth of the area in the late 1800s, coal was needed as part of the steel-making process.

The mines in and around Patton Township had a single point of entry. They were room and pillar mines, where miners worked "rooms" between pillars of coal left standing to support the roof of the mine. A typical design would have the rooms at widths of twenty feet and the pillars at forty to sixty-foot widths. Mules were used to haul the coal from the mines to the tipples, where coal dropped by a long plane to the screens on the branch railroads.

Patton Township residents who didn't work on the farm found work either in the mines or on the railroad. Shortly after the Civil War (about 1865),

From Frontier to Boomtown

New York and Cleveland Gas Coal Co. began deep mining operations. Thousands of tons of high-grade coal were taken from the mines by pick and shovel in and around Patton Township.

The *Annual Report of the Geological Survey of Pennsylvania* for 1885–87 states that the secretary of internal affairs report showed 274 people employed around the mines in 1884 and a production level of 180,000 tons. During the peak deep mining years between 1890 and the late 1920s, about 600 coal miners lived in the area surrounding Turtle Creek, including Patton Township. The rural township benefited from the many immigrants and strangers who came to work at the Pitcairn Railyards and in the mines.

The Geological Survey report indicated that the Pittsburgh coal seam was confined to the western part of Patton Township, while the eastern area of the township was mostly just rocks. According to mining maps, the division seems to occur along the route of the Pennsylvania Turnpike.

The township's coal boom occurred about the time of World War I, when strip mining and deep mining were both taking place. Surface coal mining began changing the landscape of Patton Township, displacing some of the farms that were dug up to reach the surface coal. Two large areas of strip mining occurred along what is present-day Business Route 22, ironically in the areas where the two largest shopping areas—Miracle Mile Shopping Center and Monroeville Mall—were eventually constructed.

New York & Cleveland ran the Oak Hill mines, one of the largest ventures in the area around Patton Township. Oak Hill No. 4, located on the Bessemer & Lake Erie Railroad, was opened by New York & Cleveland about 1889. No. 4 was the main underground mine in Patton Township, located in the vicinity of James Street, Monroeville Road, Monroeville Boulevard and Johnston Road. The mine was responsible for huge subsidence pits behind Monroeville Mall, where the company maintained a barn for the mules used to pull coal cars out of the mines.

Oak Hill No. 5 was another drift and pick mine, working the eight-foot-thick Pittsburgh coal vein around the turn of the twentieth century. It was a long, irregular strip that stretched from the Plum Borough line through what is now Garden City to near the Northern Pike.

Located on the opposite hill from the Oak Hill No. 5 on the border of present-day Monroeville and Penn Hills, the Oak Hill No. 6 mine was listed as a new venture in 1903 and serviced by the Bessemer & Lake Erie line.

There was another crescent-shaped area of coal southwest of Northern Pike, near the one-room Haymaker School.

Herold & Bowers Wagon Mine operated at least from 1884 to 1923 in Patton Township. Harper No. 1 Mine was worked in the 1920s near Turtle

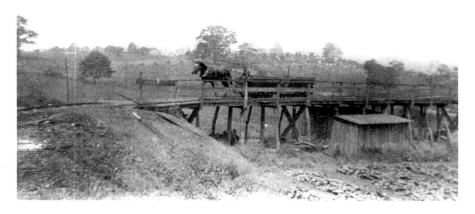

Norman Bauer drives the coal cars in the 1920s into the mine near Old Stone Church. *Courtesy Monroeville Historical Society.*

Creek. Several other coal companies operated in Patton Township: Blanchard Coal, Reynolds Coal, Dempster & Boyd, Beatty Gas and Coal, Monroeville Coal Co., John Mathews Coal and the Thomas Harper Coal Co.

Three other mines operating in the 1920s were Bolton Mine, located near Pitcairn and owned by the Pitcairn Gas Coal Co. of McKeesport; Wallace Mine, owned by the company of the same name; and Grimm Mine, owned by the Grimm Coal Co. next to Wallace Mine. Yothers Mine, which may have been a strip mine, was owned by C.B. Yothers Co. in the 1920s.

In addition to the large and small mining operations, there were many "country pits" worked by fewer than six miners that did not require plans to be filed with the government, so no maps exist of their whereabouts. And every homeowner in the rural area had his own "dog hole" to supply coal for his stove.

Since its inception in the mid-1800s, the coal industry has been plagued with problems. Thousands of miners have died or been injured in accidents, roof falls and methane gas explosions, not to mention the prevalence of black lung disease once continuous mining machines were put into operation.

The Virtual Museum of Coal Mining in Western Pennsylvania maintains an online memorial to miners who worked the bituminous seams. There some tragic stories emerge from the Oak Hill No. 4 Mine—tributes to young men and boys who paid with their lives to fuel a nation.

From Frontier to Boomtown

Joseph Jones, a coal loader, was barely a teenager when he was fatally injured as material slipped while he was standing at the end of a mine wagon on February 13, 1892. The father of the thirteen-year-old testified before a coroner's jury that he had examined the place a short time before and felt that things were safe.

Abraham Douglas was only fourteen when he was killed when coal fell in a room at the mine on June 18, 1901. He was working with his father, who failed to set sprags, or props, to the coal while undermining it.

Norman Barkley, fifteen, was a trapper boy when he was killed after being caught between a mine wagon and coal pillar on September 9, 1898. The accident happened near the entrance to the No. 4 butt entry. He died twenty-four hours after being injured.

Joseph Semmens, fifteen, was instantly killed on December 12, 1889. His father, who was working with him, stated that Joseph had sounded the coal with a pick. Before the father had time to speak to Joseph, a wagonload of coal and a ton and a half of slate fell on him.

Neglect caused the death of Robert McAlister, twenty, who was fatally injured when slate fell on him as he was knocking coal on July 7, 1892. He had two posts set under the slate, but they were too far apart for safety.

Pick miner Rodi Vaurick, twenty-two, died twelve hours after being injured when slate fell in the mine on August 22, 1898. Many other miners were injured in Patton Township's mines but survived the experience.

When the mines disappeared by the end of the 1920s, the rural community returned to its pastoral tranquility. Some accounts say that when the mines left, Patton Township became a "ghost town," as miners sought employment elsewhere. While mostly forgotten, the mines sometimes still remind the community of their hidden presence under the earth.

On September 30, 1987, a methane explosion blew off the side of a house on Johnston Road, prompting the evacuation of five families. Some blamed the nearby Chambers Development Co. landfill for off-site migration of methane, but Chambers officials suggested that the real cause was the raw sewage being dumped into underground mines that crisscross the area. Decaying sewage gives off methane—and sewage was routinely discharged from some Johnston Road homes into the abandoned mine, possibly contributing to the problem.

Property owners in the undermined sections live with the possibility of mine subsidence. In 1982, a decades-old mine fire crept too close to homes and within sixty feet of a high-pressure natural gas line near Glenwood Park in Garden City. An extensive effort was undertaken to extinguish it for good.

The greatest evidence of the mines today comes from a pipe near the Union Railroad yards at Hall Station. The pipe not only carries storm water, but also dumps daily loads of aluminum from the abandoned mines in excess of two hundred pounds, polluting water in a standing pool to the point that it's earned the name "Blue Lagoon."

Life and Death…and in Between

Every community has its tales of ghosts and things that go bump in the night. While the rumored unworldly hauntings may be scary, sometimes real life events can be even more frightening. Monroeville and the portion of the old Patton Township that is now Pitcairn Borough have their share of both.

"Walkin' Rosie," assumed to be a young woman, is one of the most notorious local specters. Many recall the tales of her nighttime strolls at Restland Cemetery in Monroeville. Rosie supposedly resembled a monument that has since been removed by the cemetery—and there is no concrete evidence that Rosie still walks.

The hilltop Fair View Cemetery, overlooking Pitcairn near the Monroeville border, is rumored to be haunted by elderly ghosts. However, rumors of white specters roaming the top of the hill may have actually had another origin. A field to the left of the old cemetery was a well-known, little-talked-about meeting place for the Ku Klux Klan.

Pitcairn also has a trail where, reportedly, those brave enough to walk the path are followed by a constant sound of footsteps at a distance of about ten paces. On trails behind the old baseball fields in Pitcairn, the ghosts of nineteenth-century workers who died in accidents at the town's rail yards are said to walk the earth. Many people were killed when the rail cars were being coupled, so this tale may be grounded in fact.

Haunted trails have been reported in the woods in other parts of Pitcairn. One, located near an old bridge over a creek, is said to be haunted by an "old man" believed to be a child molester who used the woods to commit his crimes but committed suicide when caught. He is reported to bump walkers' arms as he passes through the woods.

Johnston Road runs from Monroeville to Pitcairn and is rumored to be the home of "Shadow Man," a dim figure who haunts the Pitcairn side of the closed section of the road. People have reported hearing voices and sounds of people walking at night in that area of the woods.

Maybe they should have paid more attention to those noises, because since 1979 the bodies of three girls have been found in the vicinity of

From Frontier to Boomtown

Police from several departments, including Monroeville, searched for Beth Barr. *Photo by Dom DeDomenic, Gateway Associated Photographers.*

Johnston Road, all the victims of homicide. Beth Lynn Barr, daughter of a Wilkinsburg policeman and his wife, was kidnapped on the way home from Johnston School in Wilkinsburg at about 2:15 p.m. on Thanksgiving Eve 1977. During the investigation into Beth's abduction and murder, police followed up on thousands of leads.

Sixteen months later on March 22, 1979, Joseph Leonard of Monroeville was walking his dogs in a wooded area on Johnston Road, adjacent to Restland-Lincoln Memorial Park in an area known as a lover's lane, when he came across Beth's body. She rested in a shallow grave, barely visible under a blanket of piled brush, dirt and leaves. Her makeshift grave was a rough contrast to the nearby manicured cemetery. The victim of multiple stab wounds, Beth was found fully clothed, wearing the red pantsuit, blue tennis shoes and plaid coat she had on the day she was abducted.

The bodies of Melissa Baker, twelve, of East McKeesport and Penny Ansell, thirteen, of North Versailles were found in a dump along Johnston Road in 1988. Authorities said that Steven Mignogna, nineteen, of nearby Trafford, and a friend, Michael Gionta, twenty, of Monroeville, picked up the girls at Norwin Hills Shopping Center on Route 30 in North Huntingdon. The foursome drove to Mignogna's home in Trafford. There, Mignogna stabbed them, put their bodies in plastic bags and dumped them on Johnston Road.

Gionta, who was the prosecution's key witness, was never charged, and even Mignogna corroborated Gionta's claim of innocence. Mignogna was found guilty of murdering the two girls and sentenced to life imprisonment.

The murder of children is indeed tragic—and there are others in Monroeville who met their fates in accidents and incidents of domestic and other violence. But a few sensational murders stand out.

On October 13, 1994, the severed arm and legs of Faye Marie Jackson, twenty-four, also known as Faye Norris, were found in a creek bed along Route 286 in Monroeville. About two weeks after the body parts were found, Jackson was identified using fingerprints from the arm that was recovered.

She had last been seen three days before in the Pittsburgh city neighborhood of Garfield, where she reportedly lived and worked as a prostitute. The cause of her death could not be determined. The rest of her body was never found.

In 2001, an anonymous tipster told police that Jackson's death had occurred in a hotel or motel in the Monroeville area and that the body had been disposed of in dumpsters. The tipster also told police that more than one person was involved in her death.

One of the most sensational murders of all time was that of Harry McMasters, thirty-five, proprietor of the Hi-Hat Club, a popular nightclub on the first William Penn Highway at the corner of Haymaker Road. McMasters, who owned the club with his brother, Gerald J. McMasters, thirty-three, of Pitcairn, was stabbed and tortured as he headed down William Penn Highway one night in 1937. The brothers also owned Alpine Country Club along the Patton Township highway.

Seven ace sleuths of the Allegheny County detective bureau were assigned to investigate the mysterious stabbing. Before he died the next morning at 7:15 a.m. on September 15 in West Penn Hospital, McMasters was able to tell them that he drove about three miles along William Penn Highway after leaving his nightclub when he stopped to render assistance to three young men who were fixing a tire along the road. The men demanded $100, but he told them he only had $5. The trio jerked him roughly from behind the wheel of his car and threw him to the side of the road, where they beat him and tortured him with a knife.

The men cut off his necktie and coat, pulled off his trousers and shoes, slashed his shirt to ribbons with knives and pressed lighted cigarettes against his neck, chest and toes. When he attempted to resist, a bandit inflicted three stab wounds in his right side, one of which penetrated his lung.

Despite his injuries, the partially clad McMasters drove back to the club, where he was treated by a physician. A few hours later, his brother Gerald

From Frontier to Boomtown

HARRY J. MacMASTER. Stabbed by three young men in William Penn highway, Patton township, last Friday morning Harry J. MacMaster, 35, co-proprietor of the Hi-Hat night club in Patton township, died yesterday in West Penn Hospital.

Harry McMasters, proprietor of the Hi-Hat Club, from an unidentified newspaper clipping.

rushed him to the hospital, where he lapsed into unconsciousness and died from an internal hemorrhage. While still conscious, McMasters told detectives repeatedly that he did not know the men but was able to give a meager description of clothing worn by one of them.

Detectives puzzled over another cut apparently made by a knife in the back of McMasters's coat, especially since no wound was found on his back. They believed that the men may have known him—possibly even frequented

the roadhouse and knew his habits, including that he may have had carried more than five dollars.

They also considered the possibility that a jealous woman might have participated in the attack. Fingernail scratches on his face pointed to the presence of a woman, whom investigators said may have led or instigated the assault. One newspaper account stated that detectives "were believed to have a live clue which they have been forbidden to reveal."

Gerald continued to run the club until he died of pneumonia. The club had been vacant for five years when a mysterious fire completely destroyed it.

Together for Eternity

Today, Monroeville's crossroads are located where state Route 48, U.S. Business Route 22, Interstate 376 and the Pennsylvania Turnpike form an intersected knot.

For a greater part of history, though, the crossroads were where Township Road met the Northern Turnpike, today the intersection of Monroeville Boulevard and Stroschein Road. There the properties of some of the earliest families—the Snodgrasses, Johnstons, Beattys and Myerses (Mierses)—came together at the corner.

At the eastern end of what was the hamlet of Monroeville, the generations are buried together in what is known today as Historic Cross Roads Cemetery or Cross Roads Presbyterian Cemetery.

The first burial that took place within the confines of the cemetery is shrouded in a confusing mystery of history. As the story goes, a young child wandered away from the Captain Robert Johnston homestead in the late fall or early winter sometime prior to 1796. All efforts to find the child before heavy snows fell a few days later failed until the next May, when Captain Johnston discovered the body after the snow thawed. The child was found on a knoll that had not been previously searched about a mile from home and was buried at the site.

One version suggests that Mary Johnston, a four-and-a-half-year-old daughter of Captain Johnston and his wife, Margaret, was the child. But the family tree lists no daughter with that name, although it does list a second son, Robert, but with no details of his birth or death. There is a Mary Johnston of that generation born to Captain Johnston's twin, William, and his wife, Mary Clugston Johnston, but she survived to adulthood. However, there is a Margaret of that generation with no birth or death information listed on the

From Frontier to Boomtown

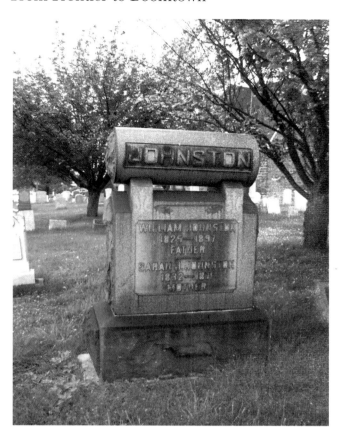

The grave of William and Sarah Johnston, descendants of one of the first settlers. *Photo by author.*

family tree. Still another tale suggests that the child was not a Johnston but was visiting the Johnstons when he or she disappeared.

Captain Johnston's sister-in-law, Mary Clugston Johnston, died in 1796 and was buried next to the child. Today, both the gravestones survive, but the child's inscription, if indeed there was one, is illegible. The plots where the two are buried are located on one of the highest knolls in the area. By 1800, Johnston had dedicated about an acre surrounding Mary's grave as a final resting place for his family and friends.

The Snodgrass family, which bought some of the Johnston farmland to help the family after Indians burned their home, decided to use acreage just east of the Johnston's graveyard for their own friends and neighbors. The large Beatty family, which owned land northeast of the original cemetery, used the lower corner of their property as a burial ground. The three independent cemeteries were adjacent to one another at the time that Cross Roads Church formed in 1836. In 1872, the church had its backyard

surveyed and laid out lots for its own cemetery, making four separate burial grounds. Finally, in 1928, the four become one through a donation and purchase of land.

In the cemetery are buried generations of some of the earliest families, whose names are remembered in the nomenclature of local roads—Beatty, Haymaker, Cooper, Abers Creek, Johnston, Ramsey, Stroschein, Speelman and McGinley.

The gravestones of soldiers show that from the country's earliest days local young men served with honor. James Gill, Robert Johnston, William Johnston, James Jordan, Robert Clugston, Samuel Snodgrass and George Lang—all Revolutionary War soldiers—are laid to rest in Cross Roads.

There are also Civil War veterans, including three who died in 1864 defending the Union. William Gill died at thirty-three on January 2 in service to his country. William J. McClelland, a private with Company A, Sixty-third Regiment P.V., was wounded in action near Petersburg, Virginia, on June 16. He died two days later at the tender age of eighteen years, five months. Matthew Aber, a corporal of the First Pennsylvania Cavalry, was wounded in action at Petersburg, Virginia, on September 30 and died October 1 at the age of eighteen years, five months and five days.

Colonel Sam Snodgrass, a veteran of the War of 1812, died in 1851 at seventy-seven years of age. James H. Newlen, 1849–1921, served his country during the Spanish-American War. Thomas Lenox Harvey, 1887–1964, served as a private, and George R. McIndoe, 1896–1958, served as a first sergeant, both during World War I.

Corporal Donald W. Glendenning, 1920–1945, was not quite twenty five years old when he was killed in action during World War II. Lloyd B. Jackson, 1906–1989, a master sergeant with the Eleventh Army Division, earned three Bronze Stars and a Purple Heart during his service in World War II and the Korean War.

Not everyone served during wartime. Thomas Andrew Kinney, 1960–2004, was a Hospital Corpsman, Master Chief (HMCM) Seal for the U.S. Navy. Private First Class Joseph H. Scull, 1901–1974, served with the Seventh Cavalry during peacetime. Nino Falcocchio, who died in 2009, was a World War II army veteran who, as a draftsman, contributed his experience to the first nuclear submarine, the USS *Nautilis*.

There are also public servants who have their final resting places in Cross Roads Cemetery. George Gregowich Jr., 1924–1985, served as Monroeville's police chief for many years. Walter Stroschein, who died in 2002, was a former Patton Township supervisor. Hank Itri, 1938–2004, chaired the Monroeville Planning Commission and served on Monroeville Council.

From Frontier to Boomtown

Some of the oldest tombstones at Cross Roads Cemetery are barely legible today. *Photo by author.*

Jack Sedlak, 1932–1995, was also a Monroeville councilman, and today an annual Jack Sedlak Cleanup Day is held in his memory.

Miles Span, 1918–1993, among Monroeville's most memorable politicians, is buried at Cross Roads next to his son, Miles Span Jr., 1956–1982. The elder Span's contemporary tombstone speaks to his personality:

> *The greatest of these is love. Love of family...Love of community... Library Board, Little League, grants for Bel Air Municipal Pool and fire rescue equipment, Pittsburgh History and Landmarks; Man of the Year: Dapper Dan, Monroeville, Times Express; Monroeville Council—1971– 1991. Love of life itself...Did I ever tell you that I dated one of the Andrews Sisters...had three screen tests...FDR rode in my Packard in Pittsburgh...worked in a steel mill...*

The fabric that weaves together the generations of the community is seen among the gravestones. Abraham Taylor, owner of Rising Sun Inn along Northern Pike, is there, along with Allan Behler, who owned and operated LaBarbe, the barbecue stand turned nightclub on Old William

Penn Highway. James and Jennie Young, the husband and wife who ran a produce stand in an area that became known as Young's Corner, join Daniel and Margaret McMaster, whose McMaster's Grove served as a community gathering place for picnics and celebrations in the early 1900s.

Thomas Chalmers Robinson, a Turtle Creek doctor who died in 1904, rests at Cross Roads, as does one of Cross Roads Presbyterian Church's early ministers, the Reverend Robert Carothers. George W. Warner lies next to Nancy King, whom he married after the death of his first wife, Sarah (daughter of Abraham Taylor). Their son, William Horace "Hook" Warner, first president of the Monroeville Area Chamber of Commerce, Hook's wife, Leonora Beatty Warner, and other relatives are located nearby.

Pioneers and farmers, doctors and laborers, mothers and fathers, daughters and sons—all find a place to rest their heads for eternity in Monroeville—at the crossroads to a better place.

BIBLIOGRAPHY

Allegheny County PAGenWeb Archives—Tombstone Photos. "Allegheny County, PA, Crossroads Presbyterian Cemetery," 1997. http://www.usgwarchives.org/pa/allegheny/tsphotos/crossroadspresby-monroeville-index.htm.

Bethel United Presbyterian Church. Message placed in Bicentennial Time Capsule, April 22, 1976.

Bicentennial Historical Yearbook, 1951–1976. Monroeville, PA: Municipality of Monroeville, n.d.

Board of Commissioners for the Geological Survey. *Annual Report of the Geological Survey of Pennsylvania for 1886.* Harrisburg, PA: Board of Commissioners for the Geological Survey, 1887.

Bridges and Tunnels of Allegheny County and Pittsburgh, PA. http://www.pghbridges.com.

Chandler, Louis. *Getting Around: A History of Travel in Monroeville.* Monroeville, PA: self-published, 2006.

———. *Monroeville: A Pictorial History.* Monroeville, PA: Monroeville Historical Society, 2009.

———. *A Tour of Some Significant Houses in Monroeville, Pa.* Monroeville, PA: self-published, 2007.

Bibliography

Chandler, Marilyn Grace Truan. *Hamlet to Highways: A History of Monroeville, Pennsylvania*. Monroeville, PA: self-published, 1998.

Colbaugh, Jean Winkler. Interview by Daniel Nowak II and Kathleen Nowak. January 30, 1986.

Damon, Paul. *Cross Roads Presbyterian Church, Monroeville, Pennsylvania: A Sesquicentennial History, 1834–1984*. Monroeville, PA: Damon Publishing, 1996.

———. *The Story of the Old Stone Church and the Cross Roads Cemetery*. Monroeville, PA: self-published, 1996.

Davison, Elizabeth M., and Ellen B. McKee, eds. *Annals of Old Wilkinsburg and Vicinity*. Wilkinsburg, PA: Group for Historical Research, 1940.

Dawn of the Dead (1978)—Trivia. Internet Movie Database. http://www.imdb.com/title/tt0077402/trivia.

Earle, Alice Morse. *Stage-coach and Tavern Days*. New York: MacMillan Co., 1902.

Futrell, Jim. *Amusement Parks of Pennsylvania*. Mechanicsburg, PA: Stackpole Books, 2002.

"Historical Review of Monroeville, Pennsylvania to Commemorate Monroeville's 50th Anniversary, 1951–2001." Monroeville, PA: Monroeville Historical Society, n.d.

History of Allegheny County. Chicago: A. Warner & Co., 1889.

L.H. Everts & Co. *History of Allegheny County, Pa*. Philadelphia: Press of J.B. Lippincott & Co., 1876.

Meckly, Eugene P. "The Technical Information Facility of Koppers Research Center." *Journal of Chemical Information and Modeling* 8, no. 2 (May 1968).

Monroeville Historical Society. http://www.monroevillehistorical.org, and miscellaneous documents within collection.

Bibliography

Murrysville Women's Club. "This Is Murrysville." Murrysville, PA: Murrysville Women's Club, 1959.

Pennsylvania Highways. http://www.pahighways.com.

Pennsylvania State Historic Preservation Office. *Pennsylvania Archives*. Vol. III. Third Series. Harrisburg: Pennsylvania State Historic Preservation Office, 1896.

Phelps, H.M. "Inns of the Revolutionary Days: Taverns Where Weary and Dust-covered Travelers Were Cared For." *Pittsburgh Dispatch*, May 22, 1910.

"Pitcairn, Pennsylvania: Our First 100 Years, 1894–1994." Pitcairn, PA, n.d.

"Pitcairn, Pennsylvania 75th Anniversary Souvenir Book, 1894–1969." Pitcairn, PA, n.d.

Queen Aliquippa Daughters of the American Revolution Chapter writings, n.d.

Russell, Margaret. *A History of Monroeville*. Monroeville, PA, n.d.

75th Anniversary of the Westinghouse Air Brake Co. Wilmerding, PA: WABCO, 1944.

"75th Anniversary Souvenir Booklet, 1892–1967." Turtle Creek, PA, n.d.

Stevenson, Bill. Allegheny County survey form. Allegheny County Historic Site Survey 1979–1984. Pittsburgh, PA: Pittsburgh History and Landmarks Foundation, n.d.

Thompson, Sarah Sylves. *Monroeville 1774–1974*. Pine Hill, PA: self-published, 1974.

Turtle Creek Valley Historical Society. *Martha Miers: A Home in Turtle Creek*. Turtle Creek, PA: Turtle Creek Valley Historical Society, 2006.

Bibliography

Turtle Creek Watershed Association. *2005 Abandoned Mine Drainage Comprehensive Strategy*. http://tcwa.org/B/linked%20materials/2005AMDStrategy.pdf.

U.S. 22—The William Penn Highway—Highway History—FHWA. U.S. Department of Transportation, Federal Highway Administration. http://www.fhwa.dot.gov/infrastructure/us22.cfm.

Washlaski, Raymond A. *Virtual Museum of Coal Mining in Western Pennsylvania*. Pittsburgh: Twentieth Century Society of Western Pennsylvania, 2008.

"Where Wild Plum Trees Grow: Bicentennial Edition of Plum Borough History, 1788–1988." Plum, PA, n.d.

Wood, Charles. "The Boardwalk Amusement Park." *Amusement Park Management* (November 1930).

Newspapers

Daily Tribune

Gateway Newspapers

Pittsburgh Business Times Journal

Pittsburgh Post Gazette

Pittsburgh Press

Pittsburgh Sun-Telegraph

Pittsburgh Tribune-Review

Times Express

ABOUT THE AUTHOR

Zandy Dudiak is news editor for the *Times Express*, the weekly newspaper serving Monroeville and Pitcairn. During her writing career covering Pittsburgh's East Suburbs for Gateway Newspapers, a part of Trib Total Media, and other publications, she has won more than eighty national, state and regional journalism awards. Dudiak grew up next door to Monroeville in Penn Hills and retains her own childhood memories of Monroeville's development, Burke Glen's pool, Kaufmann's Tic Toc Shop and many of the mom and pop businesses that have disappeared over time. She is particularly fascinated by the evolution of Northern Pike into today's highways.

Visit us at
www.historypress.net